IMAGES
of America

CRAVEN COUNTY

IMAGES
of America

CRAVEN COUNTY

Lynn Salsi and Frances Eubanks

ARCADIA

Published by Arcadia Publishing,
an imprint of Tempus Publishing, Inc.
2 Cumberland Street
Charleston, SC 29401

Printed in Great Britain.

Library of Congress Catalog Card Number: 2001086345

For all general information contact Arcadia Publishing at:
Telephone 843-853-2070
Fax 843-853-0044
E-Mail sales@arcadiapublishing.com

For customer service and orders:
Toll-Free 1-888-313-2665

Visit us on the internet at http://www.arcadiapublishing.com

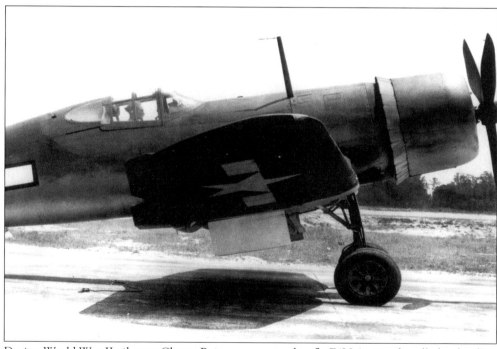

During World War II pilots at Cherry Point were trained to fly F4U-1 aircraft, called "whistling death" by the Japanese because of the drone of the engines. (Courtesy Marine Corps Air Station, Cherry Point.)

CONTENTS

ACKNOWLEDGMENTS

This book would not have been possible without the enthusiastic support of Burke Salsi and Larry Eubanks. Thanks also go to the following individuals and organizations:

Bo and Brian Salsi, Candace Hentschel, and Ashley Eubanks for sharing our history lessons.

Many people connected with the Tryon Palace Commission who were helpful in sharing information, directions, and suggestions, including Simon E. Spalding, Living History Programs Manager; Carl Herko, Communications and Marketing Director; and Brenda M. Woodington, Group Sales Coordinator.

Connie Mason for her vast knowledge and willingness to share it.

Andrew Duppstadt, costumed interpreter/history instructor at Tryon Palace and a font of knowledge.

Archivist Steven Massengill of the North Carolina Division of Archives and History.

Agnes Bizzell-Colden of the James City Historical Society and James City Smart Start Program for her help on the James City chapter.

Mrs. Sadie Hill, Mrs. Sophia Worrel Lewis, and Mrs. Shirley Moore, and Mrs. Carlotta Cooper for their memories of James City.

Victor Jones of the Kellenbergher Reference Room at the New Bern-Craven County Public Library for his interest and help on this project.

Mr. and Mrs. Richardson, owners of Bellair Plantation, for being so helpful.

The many people at Cherry Point who were courteous and helpful. We especially thank Lt. Don Caetano and Maj. Charlie Olson (retired).

Kelly Overcash and the Havelock Historical Preservation Society.

Mr. Ben Gaskill, director of the New Bern Firemen's Museum, for sharing his wonderful stories. He truly knows New Bern's fire history.

Mrs. Betty Thomas, Miss Wilda Thomas, and the deGraffenreid Society.

Baron and Baroness Helmut deGraffenreid of Bern, Switzerland.

Janice Cannon and Robert C. Blades.

Mrs. Nettie Willis Murrill for her memories of visiting Traders.

Col. Joe Carraway for sharing memories of his aunts, Rose and Gertrude Carraway.

Peter Sandbeck of Colonial Williamsburg for getting us on the right track.

The Sheraton Grand Hotel in New Bern for photo access.

Madge Guthrie for her photos and knowledge of Harlowe.

Edwin Jackson for aerial photos.

We gleaned facts, dates, and locations from the following published references:

Wind Sock, a publication of Cherry Point Marine Corps Air Station, and *A History of New Bern and Craven County* by Alan D. Watson, published by Tryon Palace Commission in 1987.

A New Voyage to Carolina, by John Lawson, edited by Hugh Talmadge Lefler, UNC Press.

James City: A Black Community in North Carolina, by Joe A. Mobley, NC Division of Archives and History.

INTRODUCTION

The history of Craven County is as old as the history of North Carolina. Its colonization figured dramatically in the settlement of the state. For the founding of this special place and the settling of the land in and around New Bern coincided with the establishment of North Carolina's first city, Bath. In 1710 New Bern became the second city. Craven County, which was first known as Craven Precinct, was established in 1712 and was named for Lord Craven of Combe Abbey in England.

The settlement of Craven was planned first in the imaginings of men, then on paper, and with the immigration of Germans and Swiss, it became a reality. Before streams of colonists virtually invaded the area, the land was in the care of American Indian tribes. Colonial beginnings included exploration and mapping by John Lawson, Queen Ann's surveyor, followed by the establishment of a permanent settlement led by Baron Christof de Graffenreid of Switzerland. The area was known to have sandy banks, shallow inlets, and a hazardous access from the sea. The English obviously gave the baron a nice build-up to convince him to risk his fortune on a settlement in the New World. New Bern became the center of government in the new colony and was known abroad as an island of civilization in America.

The study of Craven County is a history of growth, change, and development. The county's society, wealth, and progress have been tempered by and stimulated by the realities of war. The Revolutionary War had a great impact due to the pervasive influence of the elite and the representation of the king. Almost 100 years later colonial influences were lost as the Civil War dramatically changed the county, forcing the citizens under the laws of Federal troops. Many residents fled, never to return, and the town lost its pre-war status and wealth. The antebellum glory was never regained, yet through persistence and hard work, the townspeople prevailed.

We wondered how we could ever compress so much history into one volume, until we ultimately realized there was a clear dividing point which dictated the culture, growth, and future of Craven County—the Civil War. Life before, during, and after the war constitutes three distinctive periods of history and accomplishment. We chose to begin our storytelling journey in 1884, 20 years after the Civil War, when William Garrison Reid returned to Craven County where he had served with the 44th Massachusetts Volunteers Regiment in 1862.

The story of Craven is ever unfolding, melding the past with modern progress. We have attempted to strike a balance of history, preservation, and future. The prosperity of Craven County has often been interpreted through its connection with other counties, its establishment of industry, and its position in agriculture. No matter the issue, transportation has always been at the forefront. The earliest people had to conquer rivers and streams by constructing bridges and ferries. In 1858 the railroad brought the construction of a railroad bridge over the Trent River and the promise of connecting the rural eastern coastal area to the rest of the state. Craven County has never stopped connecting products, markets, and people to the land. With completion of the Neuse River Bridge in 2000, Craven County bridged the past to the future one more time.

One

A BRIDGE TO THE
FUTURE, 1884

*On October 4, 1884, William Garrison Reed, a veteran of the 44th Massachusetts Volunteer Militia,
returned to North Carolina to visit sites in Craven County where he had served during the Civil War.
The photographs Reed took give us a capsulated visual story of the look of Craven County just 20 years
after the Civil War. They mark the transition of the old Craven County to the new Craven County—
the period when residents clearly remembered past hardships and were looking forward to the future. By
the time he returned to the county, the old ways had been virtually erased. Reed found the vestiges of
war mostly buried under farms, new neighborhoods, and parks. There were no traces of the military
regime; instead he observed people getting on with their day-to-day lives.*

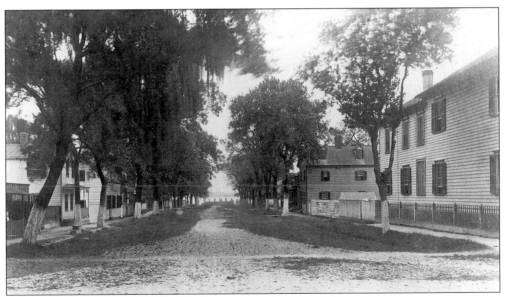

This view of Broad Street in New Bern looks toward the Neuse River and shows the grand 18th-
century and Victorian homes set close to the tree-lined avenue. In 1884 Garrison found the
lower end of the street to have very little traffic. Grass had overgrown the wide lane, leaving a
narrow path. In the 1950s Broad Street was widened to a four-lane thoroughfare, and the John
Lawson bridge was constructed at the end of the street connecting New Bern to other parts of
the county. (Courtesy North Carolina Division of Archives and History, William Garrison
Reed Collection.)

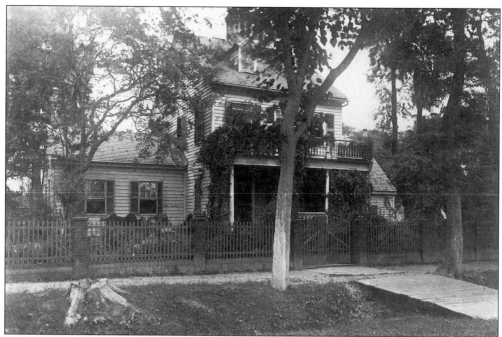

Reed photographed the Radcliffe House on Broad Street in New Bern in October 1884. During the war the private home was confiscated by Union troops and used as the quarters of the 44th Massachusetts Regiment, Reed's old outfit. (Courtesy North Carolina Division of Archives and History, William Garrison Reed Collection.)

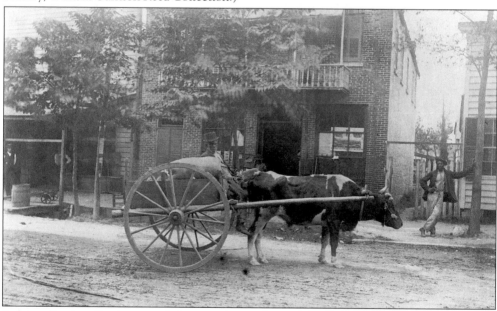

In his collection, Reed captured the everyday working of the city of New Bern after the Civil War; in this image an ox cart is loaded with supplies. The roads and streets of Craven County were unpaved and often only wide enough for a horse and cart—the year 1884 was long before the invention of the automobile and paved roads. (Courtesy North Carolina Division of Archives and History, William Garrison Reed Collection.)

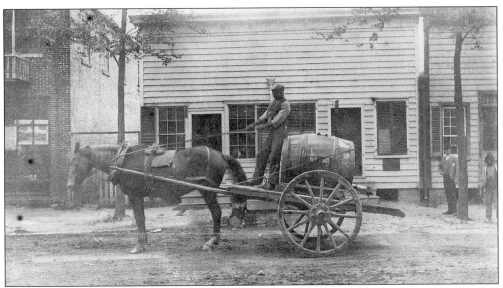

A watering cart was used to sprinkle the New Bern city streets to keep the dust to a minimum. The driver pulled up to the city well, barely visible behind the cart, to fill the barrel. (Courtesy North Carolina Division of Archives and History, William Garrison Reed Collection.)

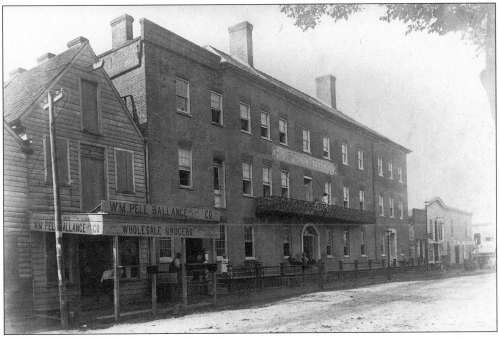

The Gaston Hotel, named for William Gaston, was located on the 300 block of South Front Street and was the county's oldest hotel for many years. It was opened in the 1850s under proprietor William P. Moore and was modernized in 1858 with gas lights. During the Federal occupation of New Bern, the hotel was reserved for officers. Garrison stayed there for the first time on his visit in 1884. The William Pell Balance Wholesale Grocers can be seen in the foreground. (Courtesy North Carolina Division of Archives and History, William Garrison Reed Collection.)

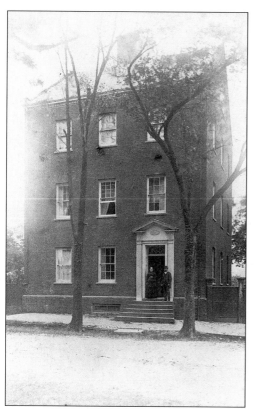

While Reed was in New Bern during the war, the Isaac Taylor house was the headquarters for the 44th Massachusetts Regiment. The brick house was built in 1792, with three stories above a basement. It is still standing at 228 Craven Street. There is a popular legend that two old maids resided on the third floor, and when the Union troops occupied the city, they refused to leave. They stayed in the house and refused to associate with the Yankees. (Courtesy North Carolina Division of Archives and History, William Garrison Reed Collection.)

The old Patterson house was a private home that served as the provost marshal's office and guard house during the war. The house changed very little from the Civil War until William Garrison Reed took this photo in 1884. Shortly after Reed's departure, Appleton Oaksmith purchased the house and completely remodeled the structure, turning its exterior into a showplace with dormers, balconies, and an elaborate tower. (Courtesy North Carolina Division of Archives and History, William Garrison Reed Collection.)

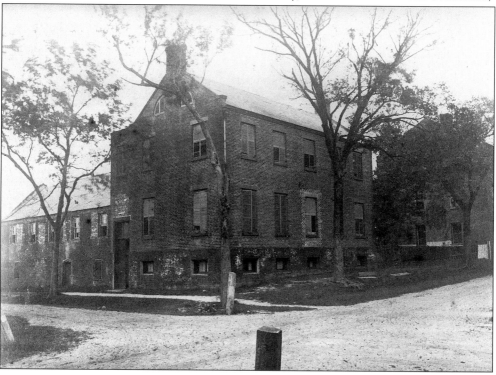

The United States National Cemetery was established in 1867 on land adjacent to New Bern near Jack Smith Creek. National Avenue was constructed by the federal government to reach the cemetery and was maintained by the government as an access road. The original lodge, pictured here in 1884, is no longer standing; however, the cemetery has been maintained and improved over the years. (Courtesy North Carolina Division of Archives and History, William Garrison Reed Collection.)

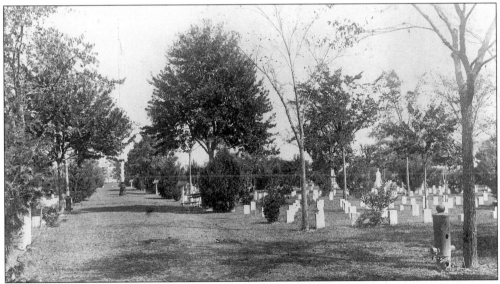

When the National Cemetery opened, bodies of Union soldiers who had died in Eastern North Carolina during the Civil War were transferred from many other cemeteries and re-interred. At the time of this photograph, the cemetery was still considered "out in the country." In 1867 the federal government constructed and maintained National Avenue from New Bern to the cemetery. As a result of the new road, the Riverside subdivision was begun in the early 1900s and the area developed as part of New Bern. (Courtesy North Carolina Division of Archives and History, William Garrison Reed Collection.)

This is how the inside of Fort Totten appeared 20 years after the war. At the time of its construction, it was pentagon-shaped, mounted 26 guns, and was considered the largest and strongest fort built by the Union army in Craven County. The fort was located on the outer edge of New Bern and was one of many fortifications that were erected to protect the Union stronghold. (Courtesy North Carolina Division of Archives and History, William Garrison Reed Collection.)

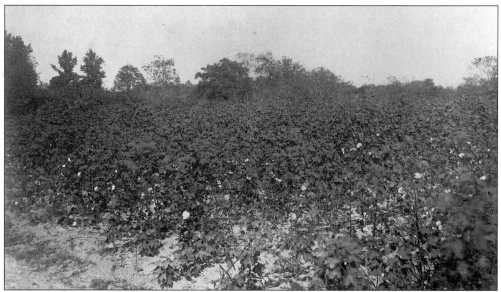

This exterior view of Fort Totten shows that huge mounds of earth were still in place in 1884. It was recorded that 5,000 freedmen helped build this fortification when the federal government employed men from James City to carry out the manual labor required. Today, traces of Fort Totten remain under the improvements of a city park. (Courtesy North Carolina Division of Archives and History, William Garrison Reed Collection.)

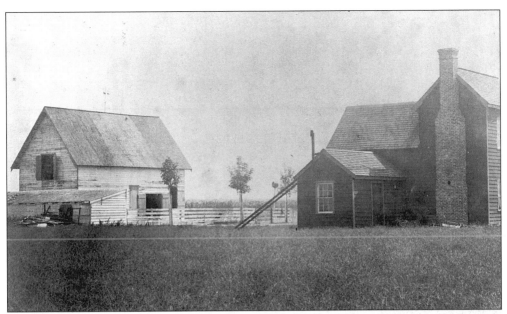

On his return, William Garrison Reed searched for the old campground of the 44th Massachusetts Regiment in 1884. Twenty years later he found a large farmhouse, barn, and fencing that had been constructed on the site. (Courtesy North Carolina Division of Archives and History, William Garrison Reed Collection.)

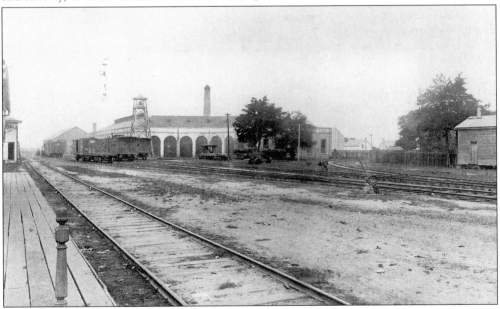

Transportation was central to the success of Craven County from its beginning as a colonial town. When the train connected the area with the coast, Goldsboro, and beyond, it was the beginning of a promising future. The first train of the Atlantic and North Carolina rail line arrived on April 29, 1858. It brought passengers and freight to Craven County and stations in New Bern and Havelock. Reed's 1884 photo shows the original frame depot and the brick roundhouse. The brick depot replaced the original around 1910. (Courtesy North Carolina Division of Archives and History, William Garrison Reed Collection.)

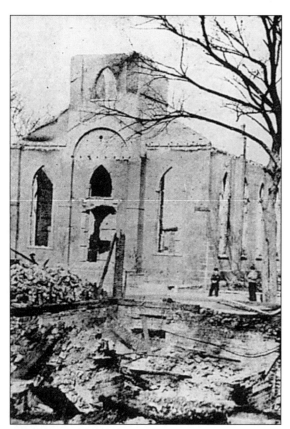

This photograph shows the ruins of Christ Episcopal Church after its destruction by fire on January 10, 1871. The building was constructed in 1824 and replaced an older sanctuary. The fire broke out in the bakery across the street, and sparks were carried by the wind to the church's wood-shingled roof. The brick from the surviving walls of the structure were recycled and used to build the new church, which was completed in 1875. (Courtesy North Carolina Division of Archives and History.)

The New Bern Fish, Oyster, and Game Fair was held on February 26, 1897 at the fairgrounds. New Bern had an enormous fairgrounds and racetrack on George Street. The main building was originally constructed to hold a school. All the structures were destroyed by the Great Fire of 1922. (Courtesy North Carolina Division of Archives and History.)

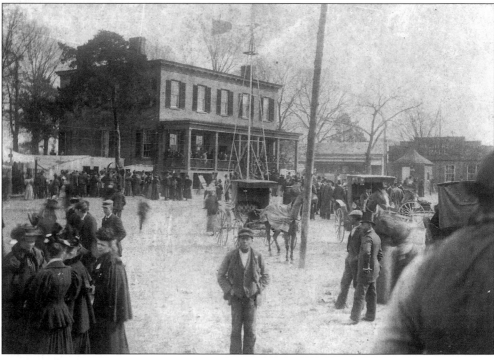

Two

NEW BERN

Nothing about New Bern's history has ever been mundane, ordinary, or lackluster. Early on, New Bern was the jewel of a newly founded county that led the way in the settlement and development of Eastern North Carolina. From its precarious beginnings throughout its colonial government, Federal occupation, Reconstruction, and progressive future, New Bern was the bastion of taste, architecture, and political ambition. In the early 1900s, it was remarked that New Bern was "the Athens of North Carolina."

New Bern rose from Reconstruction slightly scathed; yet she was never able to resume her place as the second-largest city in the state. The 1900s saw the city grow past old boundaries and establish outlying neighborhoods, connected by streetcar. World War II gave the city a patriotic punch and overflowed the city and county with new residents from every part of the United States. In the 1950s Gertrude Carraway spearheaded preservation efforts that have carried over into the new century.

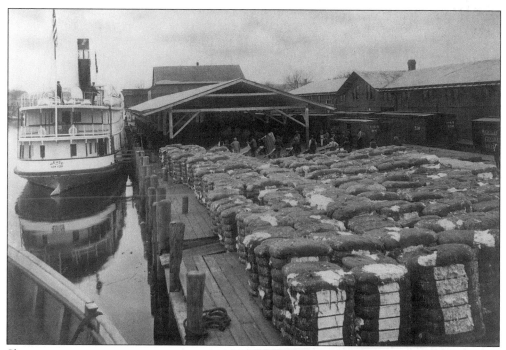

Shipping cotton was a serious endeavor. Steamers stopped at individual planters' docks up and down the Neuse River in an effort to get products—including cotton, tobacco, and produce— to market. Bales of cotton are shown taking up every available inch of space on a New Bern dock in this c. 1910 photograph. (Courtesy North Carolina Division of Archives and History.)

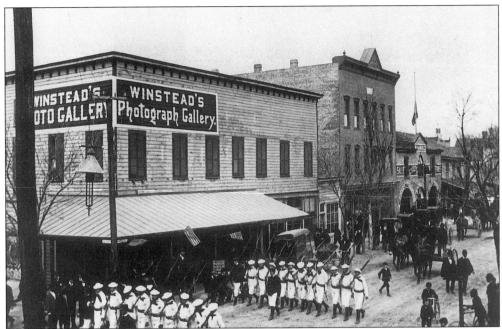

Winstead's Photo Gallery, c. 1900, was located at the corner of Middle Street and Pollock and was begun in the 1890s. It was eventually replaced by the Elk's Temple Building. Mr. Edward Gerock operated a photographic studio across the street. New Bern was home to many excellent photographers. (Courtesy North Carolina Division of Archives and History.)

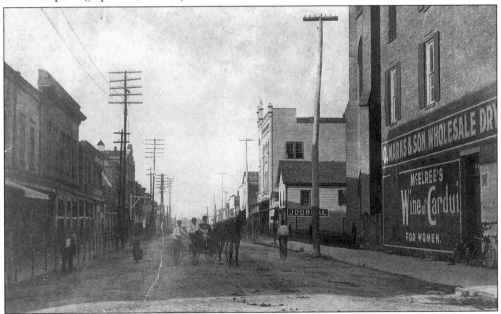

Middle Street was a main thoroughfare in New Bern at the turn of the century. O. Marks and Son Wholesale Dry Goods is seen on the right, and behind that is the *Daily Journal* newspaper office and the building that became Wootten-Moulton Studio. Bayard Wootten joined her half brother in business and, from this office, honed her craft and became the best-known photographer in North Carolina. (Courtesy North Carolina Division of Archives and History.)

Bradham's Drug Store on the southeast corner of Middle and Pollock is pictured above as it appeared in the early 1900s. The proprietor, Caleb Bradham, was best known as the inventor of Pepsi Cola. He concocted his drink in the late 1890s, applied for the trademark in 1902, and went broke when he gambled on the price of sugar. When the bottom fell out of the market, he lost his fortune and the ownership of his popular soft drink. (Courtesy North Carolina Division of Archives and History.)

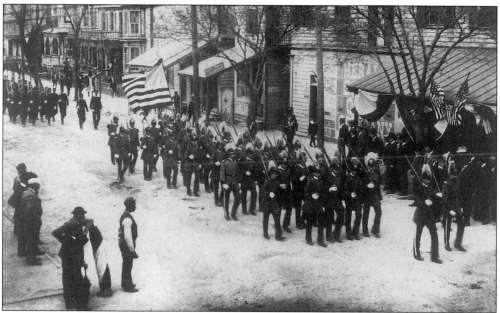

A parade is pictured on Pollock Street, *c.* 1900. Parades were a popular diversion at the turn of the century. Troops march by a row of Victorian houses that once lined the street. The Chinese laundry of Mr. Hop Wah can be seen on the left. (Courtesy North Carolina Division of Archives and History.)

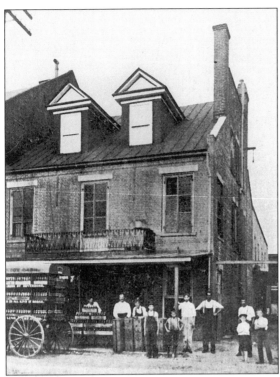

At the turn of the 20th century, local businessmen were concerned the economy depended too heavily on farms. Emphasis was concentrated on developing industry. The Crown Bottling Works on Craven Street is pictured here in 1905 and was one of four bottling companies operating in the county at the time. Root beer was one of the most popular flavors bottled. (Courtesy North Carolina Division of Archives and History.)

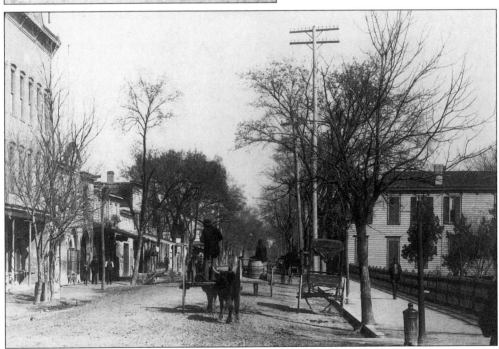

The "Lady Blessington" cannon can be seen imbedded in the sidewalk on the right of this photograph. The cannon was reportedly captured from a British ship by Privateer and Revolutionary War hero John Wright Stanly of New Bern. The relic can still be seen on the 300 block of Middle Street. (Courtesy North Carolina Division of Archives and History.)

The first New Bern Academy was reorganized after the Revolutionary War in 1784 from the first school begun by Rev. James Reed. Located on New Street, it was built with private funds and was known as the best institution of learning in the county. The second building, pictured above, was built in 1884. The old academy and the new academy were integrated into the public school system and, by 1900, were part of the Graded School. The building was used as a school until the 1970s. (Courtesy North Carolina Division of Archives and History.)

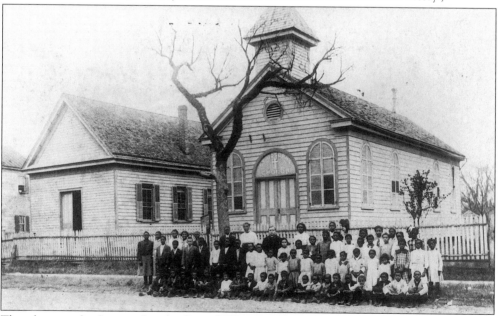

The photograph above, taken by Bayard Wootten about 1915, shows St. Joseph's Catholic Church, which was built in the 1890s. A private school was begun by the Sisters of Mercy and by 1904 was conducted as a black graded school—known as the St. Joseph's Parochial School. Later, the frame church building was demolished and a brick structure was built. (Courtesy North Carolina Division of Archives and History.)

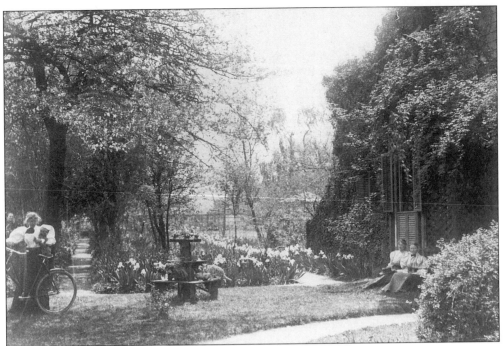

The Victorians and Edwardians loved nature and beauty, and the lush garden at the back of the Boyd House was one of the best-known Victorian gardens in New Bern. Young women in their Gibson Girl outfits are gathered here for an afternoon of leisure and perhaps cycling. (Courtesy North Carolina Division of Archives and History.)

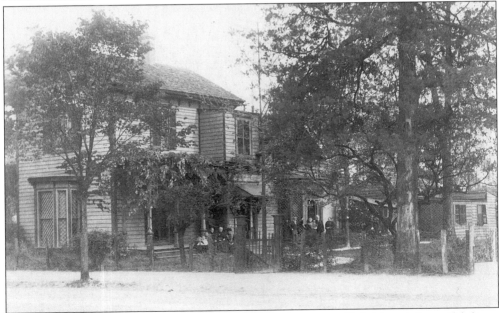

This c. 1905 view of the front of the Boyd House shows an old-fashioned, beautiful frame structure. This home was best known for its Victorian garden; however, notice the front piazza popular on most New Bern homes. Wide porches provided a respite for summer heat. (Courtesy North Carolina Division of Archives and History.)

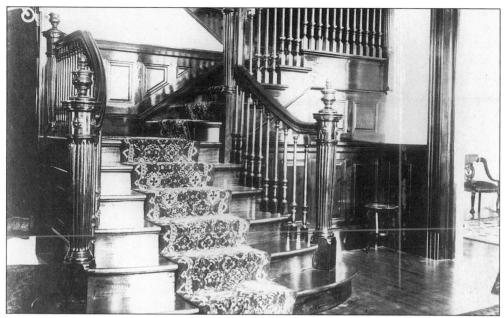

A *c.* 1910 view of the interior of the L.I. Moore House shows a highly detailed hand-carved main stairway and fine rugs, indicative of the influence of the Victorian era. Mr. Moore, a prominent attorney in New Bern, engaged the popular New Bern architect, Herbert Woodley Simpson, to design this structure. (Courtesy North Carolina Division of Archives and History.)

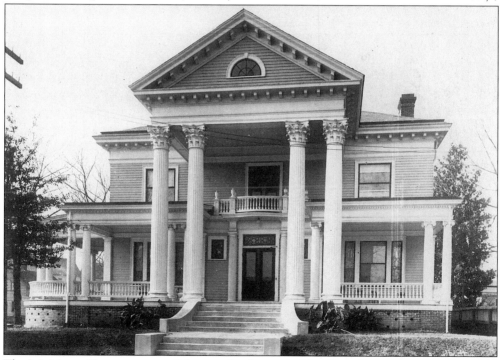

The L.I. Moore House was one of the grandest houses in New Bern. It was constructed in 1908 and was one of a number of elaborate houses designed by architect Herbert Woodley Simpson. (Courtesy North Carolina Division of Archives and History.)

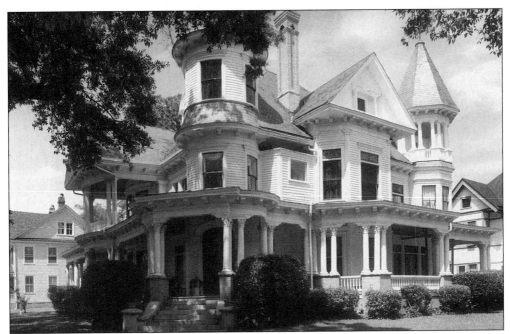

The construction of the William Blades House was funded with great timber wealth. William and his brother James moved to New Bern and became the area's wealthiest timber dealers and mill owners. His ostentatious house was constructed in 1903 and was known for the unbelievably beautiful and intricate woodwork, featuring many different types of wood in the first floor rooms. (Photograph by Frances Eubanks.)

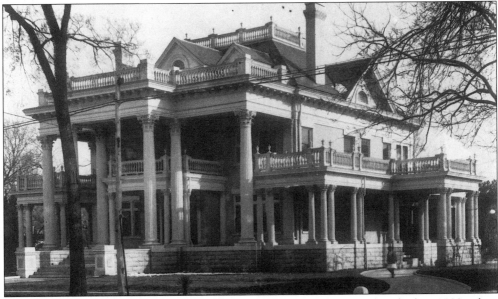

The James Vernon Blades House, pictured here c. 1913, was constructed in the late 1800s when James and his brother moved to Craven County to establish a lumber business. Architect Herbert Woodley Simpson was very much in demand at the time and designed both of the Blades homes. The house was so large that in later years it became a hotel before it was demolished in the 1960s. (Courtesy North Carolina Division of Archives and History.)

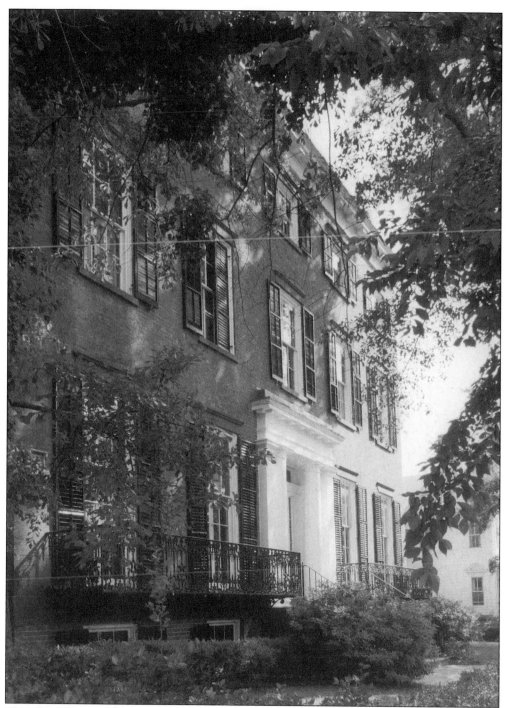

This Greek Revival house was built at East Front and Johnson Street about 1848 for Charles Slover, a merchant who engaged in trade with the West Indies. The Slovers spent the Civil War in High Point, North Carolina. In 1908 Caleb D. Bradham, the inventor of Pepsi Cola, bought the house, which is still standing at its original location. (Photograph by Frances Eubanks.)

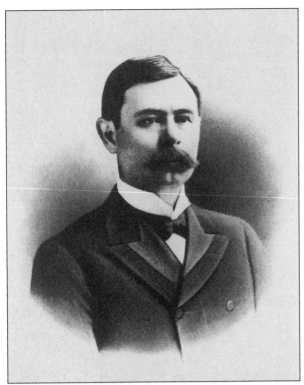

Furnifold McLendel Simmons was an attorney, a prominent political figure, and served New Bern and North Carolina for five successive terms in the United States Senate, from 1901 to 1931. Simmons was one of Washington Spivey's lawyers when the "Committee of Twelve" fought eviction from their James City land and took their case to the state supreme court. During his tenure in the Senate he wrote bills for funding for improvement of waterways for Eastern North Carolina. (Courtesy of North Carolina Department of Archives and History.)

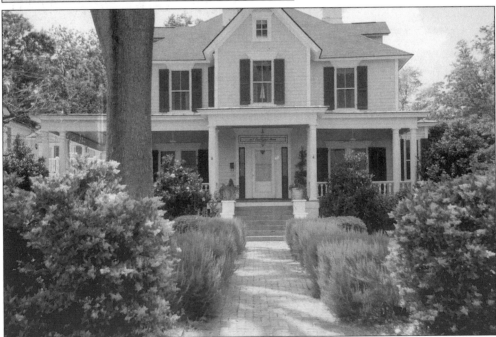

The Burris Simmons House was built in 1890, and its original owner was Walter P. Burris. The second owner was the much accomplished and celebrated Furnifold McLendel Simmons, who served for 30 years in the U.S. Senate and was chairman of the Senate Finance Committee during World War I. (Photograph by Frances Eubanks.)

Mrs. Bayard Wootten became North Carolina's best-known photographer. She turned to painting to earn a living, and became a photographer by taking photos of images she wished to paint. She worked as a portrait and publicity photographer, and in the 1930s became known for her architectural photographs. She was thought to be the first female aerial photographer, and she took the photographs from one of the Wright Brothers planes in 1912. (Courtesy of North Carolina Department of Archives and History.)

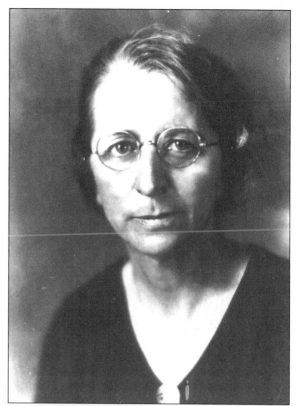

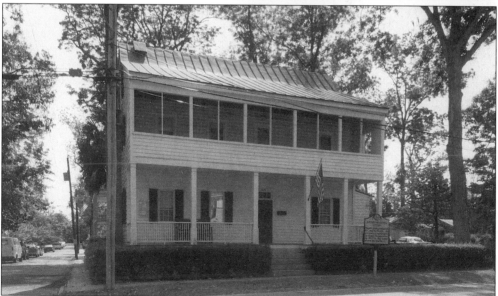

The Wootten house at 519 East Front Street was the home of Bayard Wootten, the best-known photographer in North Carolina. She joined her half brother George Moulton in business to form the Wootten-Moulton studio. Traveling throughout the state in 1920s, she contributed her photographs to many books. She was one of the first women in the United States to take aerial photographs. (Photograph by Frances Eubanks.)

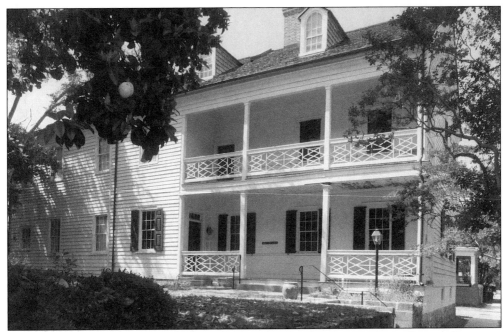

The long-framed William Gaston House is still located at 421 Craven Street. Gaston, a member of Congress and a judge of the state supreme court, was best known for writing the state song. The house has a marl (local shell rock) foundation and was originally built for James Coor, a well-known political figure from 1818 to 1844. (Photograph by Frances Eubanks.)

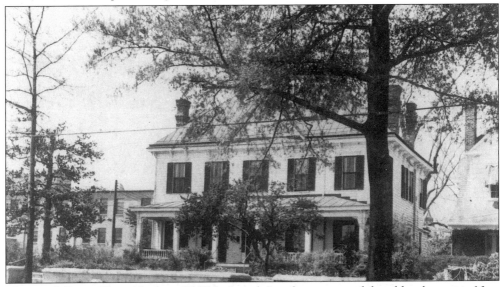

The Leech/Bryan House, built in 1763 for Joseph Leech, was one of the oldest houses in New Bern. The house changed hands many times, gaining fame when it became the temporary residence of the royal governor as His Excellency William Tryon was awaiting the completion of the Tryon Palace. During the Civil War the house served as a naval hospital. When Henry Bryan purchased the house after the war, he remodeled it from a one-story house with a dormered attic to a full two stories. This photograph was taken in the 1950s; the house was torn down in 1964. (Courtesy North Carolina Division of Archives and History.)

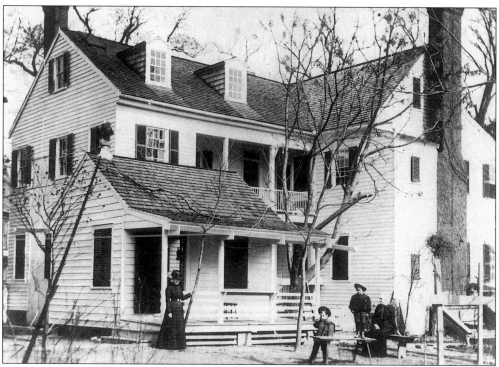

This is a view of the rear of the Jones House, c. 1900, which is located on Eden Street across from the Tryon Palace and is presently part of the Tryon Palace restoration project. During the Civil War the house was a Federal prison. Emeline Pigott, a heroine and convicted Confederate spy, was detained in the top floor of the house. (Courtesy North Carolina Division of Archives and History.)

As it stands today, the Jones House looks much as it did when it was first constructed. It has been restored to its original appearance by the Tryon Palace Commission and houses the gift shop and offices for the Palace. (Photograph by Frances Eubanks.)

Miss Gertrude Carraway was a noted New Bern historian, author, and journalist, and lived in this frame house at 207 Broad Street. She was relentless in her efforts to restore the Tryon Palace, and in 1939 located the original plans by architect John Hawks. She was successful in encouraging Mrs. James E. Latham to establish a trust for the reconstruction. The Tryon Palace Commission was created in 1945 and the Palace officially opened on April 8, 1959. Miss Carraway was honored in 1956 as New Bern's First Citizen and in 1962 was named North Carolinian of the Year. (Photograph by Frances Eubanks.)

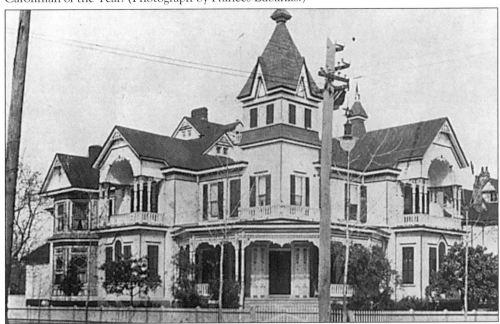

The Hughes/Stewart House, built c. 1893 by Dr. F.W. Hughes, was the largest Victorian house in New Bern. It remained the largest in town until the 1960s, when space for a city hall parking lot was needed. (Courtesy North Carolina Division of Archives and History.)

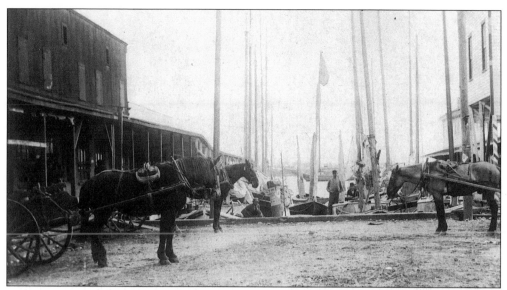

In 1901, the market docks on Middle Street were the main off-loading points for produce, cotton, fish, and other products. Much activity was attributed to the fish and oysters harvested from the Pamlico Sound and brought to be shipped. Many sailing vessels are docked and horse-drawn conveyances are poised for hauling goods to the next point. (Photo by Gerock Studio; Courtesy North Carolina Division of Archives and History.)

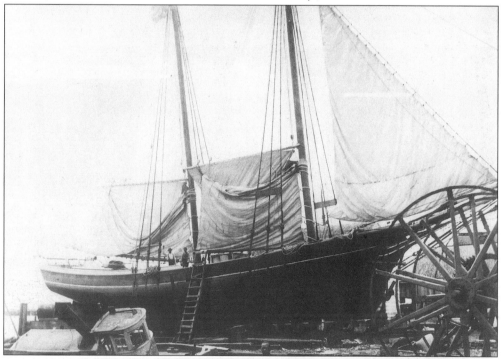

Craven County developers and politicians have always been concerned with the development of industry to help the area prosper and provide jobs for its residents. Boat building has been a long-standing industry since the 1800s. Pictured above is the New Bern shipyard, c. 1908. (Courtesy North Carolina Division of Archives and History.)

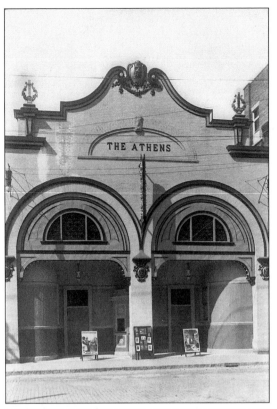

The Athens Theatre, shown here *c.* 1915, was once a truly a grand theatre. Designed by Herbert Woodley Simpson, it was completed in 1911 and was known as one of the most beautiful entertainment emporiums in the South. It hosted vaudeville troupes and was the site of many theatrical and musical presentations. (Courtesy North Carolina Division of Archives and History.)

The interior of the Athens was elaborately graced with festooned and gilded opera boxes. The main stage curtain was hand-painted with a chariot race scene from *Ben Hur*. With the advent of movies, the Athens became a movie palace. (Courtesy North Carolina Division of Archives and History.)

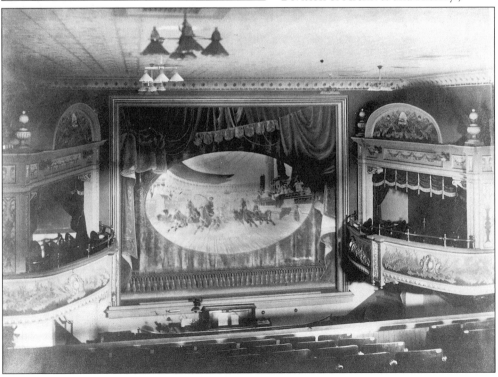

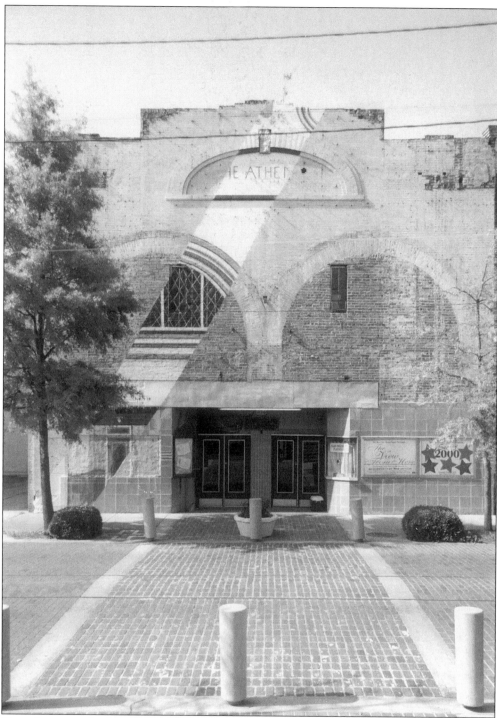

Over the years, the facade of the Athens Theatre was altered to resemble a movie theatre and the graceful building lost its charm. The movie house lasted until the 1970s, and finally closed as new theatres sprang up in shopping centers. The Athens is now the Saxe Bradbury Theatre, the home of a thriving community theatre. (Photograph by Frances Eubanks.)

In 1864 a group of freedmen protested discrimination by leaving the white Methodist Episcopal church and starting a church of their own. St. Peter's AME Zion Church, one of the first AME Zion churches in the United States, was established with the help of a missionary, Rev. James W. Hood. St. Andrew's Chapel, a Southern Methodist church, united with the AME church to become St. Peter's. The building's frame structure was remodeled and brick veneered in 1914. It was destroyed in the Great Fire of 1922, and the above structure with stained-glass windows and beautiful woodwork was completed in 1940. (Photograph by Frances Eubanks.)

St. Cyprian's Episcopal Church, built in the early 1800s, was originally constructed for the First Baptist Church. When the Baptist congregation outgrew the sanctuary, they turned the building over to the African-American congregation of St. Cyprian's Church, who used the building from 1866 until 1910. The church's present building was designed by Herbert Woodley Simpson. The church was named for an early Christian bishop of Carthage. (Photograph by Frances Eubanks.)

Christ Episcopal Church on the 300 block of Pollock Street was constructed in 1875. It incorporated the walls of the original 1824 church that had burned in 1871 (see page 16). The spire of the church reaches heavenward and is one of many spires that grace the skyline of New Bern. (Photograph by Frances Eubanks.)

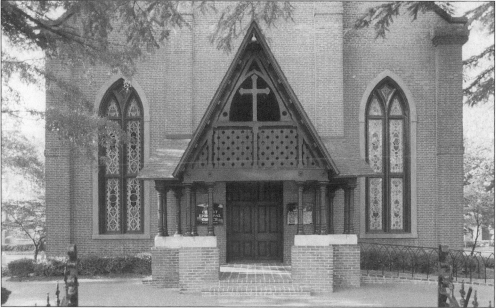

The main entrance of Christ Episcopal Church was part of the reconstruction in 1871. The silver communion service, the prayer book, and Bible presented to Christ Church by King George II of England in 1752 are still in the possession of the church. (Photograph by Frances Eubanks.)

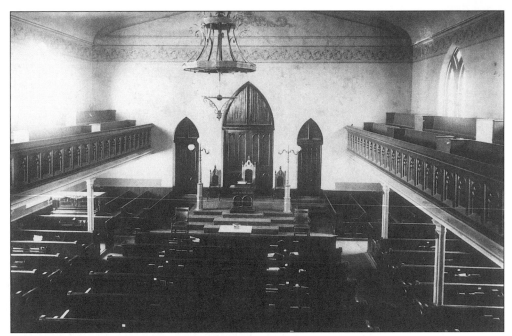

The First Baptist Church on Middle Street was organized in 1809, and the building was constructed in 1847. This early 1900s photograph shows the beautiful Gothic-revival interior that was removed in the 1940s. (Courtesy North Carolina Division of Archives and History.)

The Centenary Methodist Church was designed by Herbert Woodley Simpson and Charles Granville Jones of New York and built in 1905. It is a dramatic brick structure, combining curves, dormers, and soaring spires flanking a semi-circular main entrance. (Photograph by Frances Eubanks.)

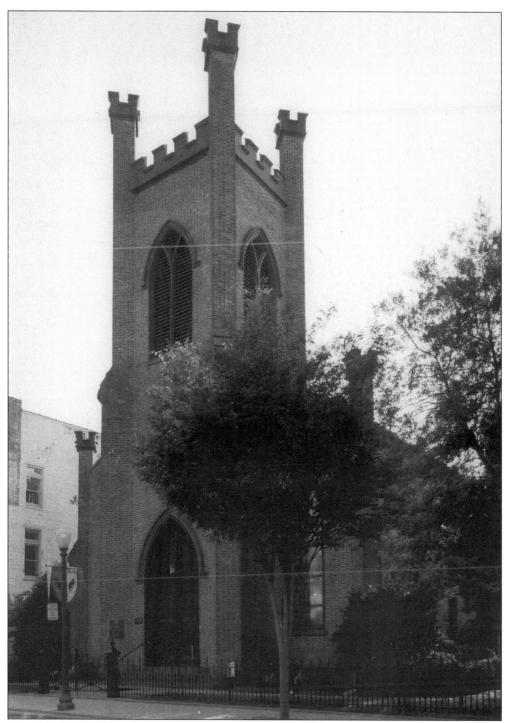

The First Baptist Church on Middle Street was designed with strong Gothic-revival detail by Thomas and Son of New York and was built in 1847. Still in use today, this building is only the second to be used by the church since its establishment in 1809. (Photograph by Frances Eubanks.)

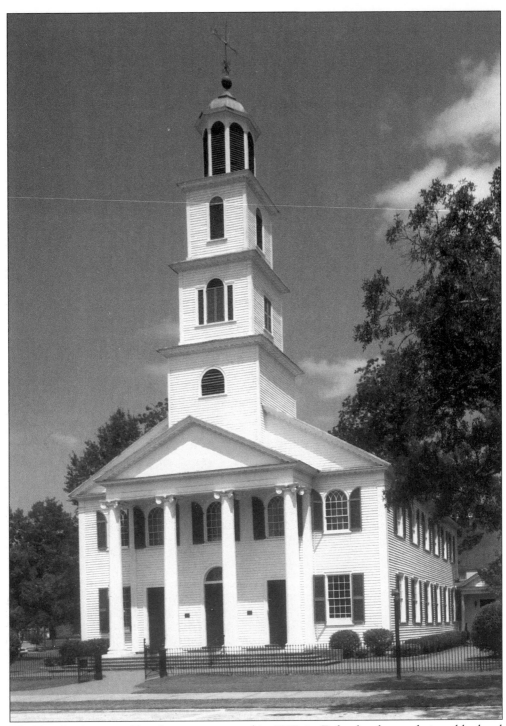

The First Presbyterian Church was constructed in 1817; its Federal style was designed by local architect Uriah Sandy. Certainly one of the most beautiful churches in the South, it is an elaborate frame structure featuring a four-story bell tower that soars into the skyline. It is the oldest church in New Bern. (Photograph by Frances Eubanks.)

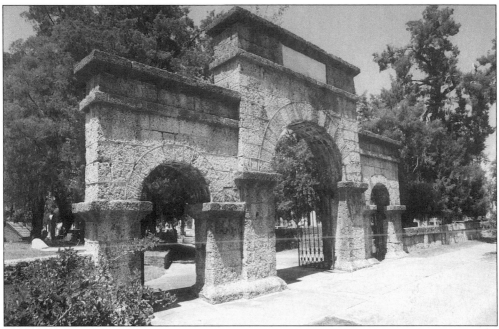

Cedar Grove Cemetery is a planned burial ground that was established after the yellow fever epidemic of 1798 filled the Christ Church graveyard to capacity. The entrance archway is constructed of marl, a very porous material. When it rains, the arch absorbs the water and causes dripping that makes the arch appear to be crying. (Photograph by Frances Eubanks.)

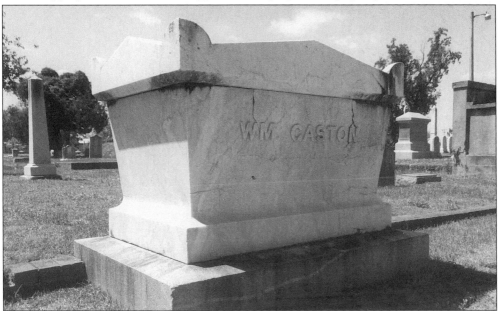

William Gaston's grave is an elegant tribute to a famous North Carolina son and statesman. The Greek sarcophagus-shaped monument was constructed of marble and was designed by New York architect A.J. Davis, who was a friend of the family. After Gaston's death in 1844, all the churches in town tolled their bells during the ninety-minute funeral service. (Photograph by Frances Eubanks.)

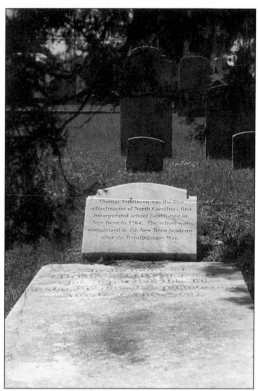

Thomas Tomlinson was the first schoolmaster of North Carolina's first incorporated school, which was established in 1764. By an act of the General Assembly in 1766, it became the first incorporated school in the province (see page 21) and later became New Bern Academy. Tomlinson was laid to rest in the Cedar Grove Cemetery, on the left of the path from the main entrance on Queen Street. (Photograph by Frances Eubanks.)

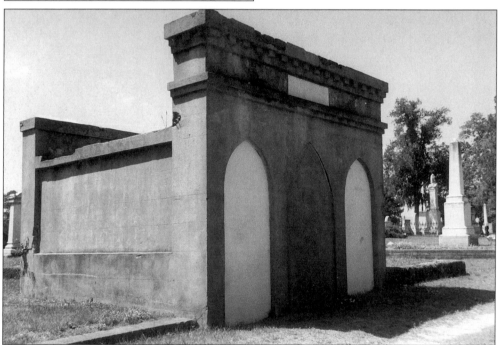

Many grand tombs in Cedar Grove Cemetery honor great families who were wealthy and politically connected. The tomb above is for the Custis family, relatives of George Washington's wife. (Photograph by Frances Eubanks.)

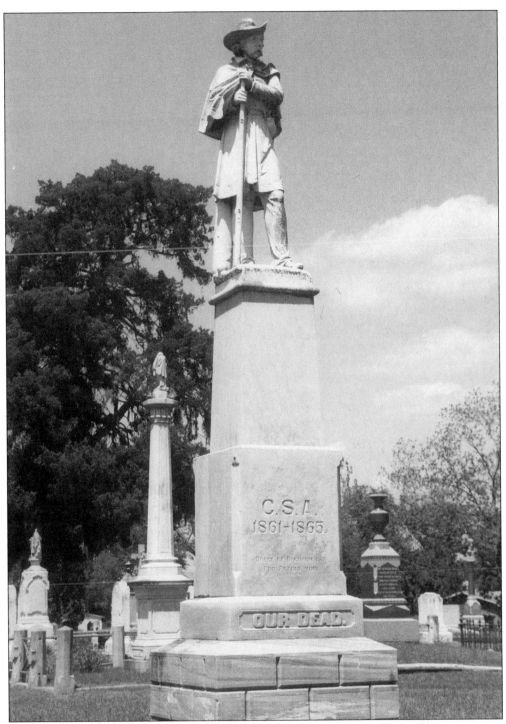

The Ladies Memorial Association erected a Confederate monument in Cedar Grove Cemetery that was dedicated in 1885, seven years after the project was begun. It was constructed over a vault containing the remains of Confederate soldiers who died in the Battle of New Bern, and was sometimes referred to as a monument to "the lost cause." (Photograph by Frances Eubanks.)

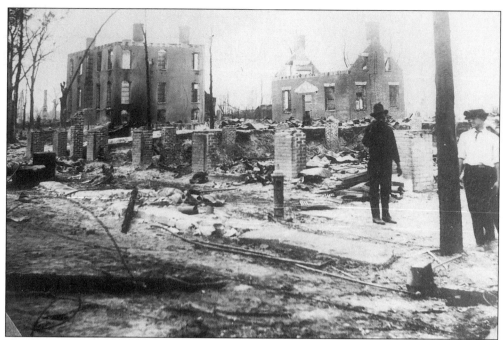

The Great Fire of 1922 will never be forgotten. The blaze began at a lumber company and the fire was reported on George Street, a well-known section of town. Separate fires continued springing up until a large area was ablaze. Forty blocks of buildings and homes were totally destroyed in this fire. The ruins of the original Griffin Free School, seen here, were located across the street from the Cedar Grove Cemetery. (Courtesy New Bern-Craven Public Library.)

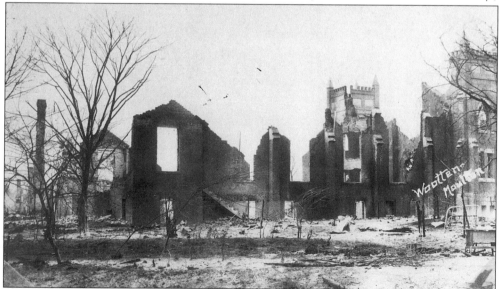

St. Peter's AME Zion Church was rebuilt after being totally destroyed during the fire of 1922. Forty blocks laid in ruins after a high wind fanned flames and caused the fire to jump from one building to another. Hundreds of African-American families were forced to live in a tent city until homes could be found. (Photograph by Bayard Wootten; courtesy New Bern-Craven Public Library.)

42

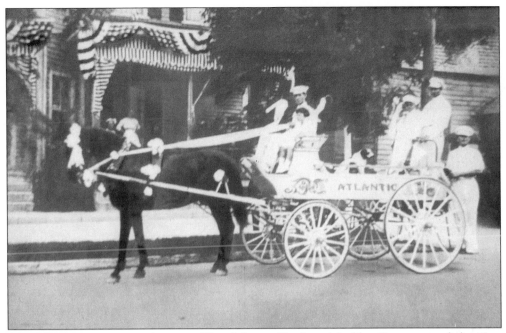

Fire fighting was a serious business. The Atlantic Hook and Ladder Company and the New Bern Steam Fire Engine Company were responsible for the protection of New Bern's downtown. (Courtesy New Bern-Craven Public Library.)

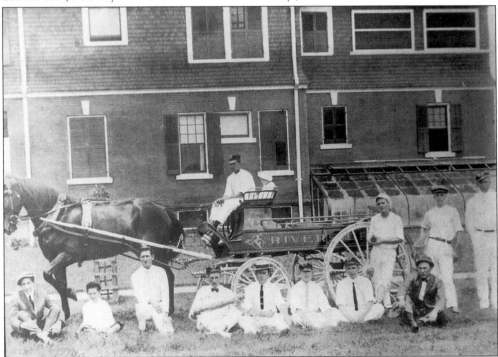

Fire companies were competitive in their response to fires. The Riverside Fire Company, one of the companies responsible for protecting areas outside of the downtown area, is pictured above c. 1910. (Courtesy New Bern-Craven Public Library.)

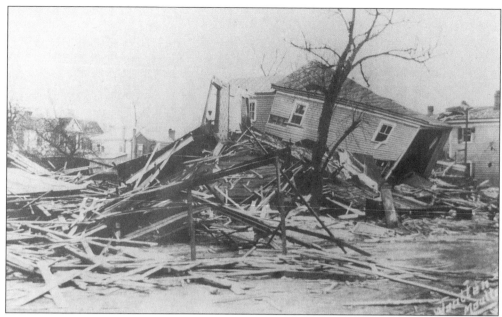

The great fire threatened to destroy all of New Bern, and fire companies arrived from all of the surrounding towns. Bayard Wootten photographed this scene after a fire break was created by pulling down and dynamiting houses. (Courtesy New Bern-Craven Public Library.)

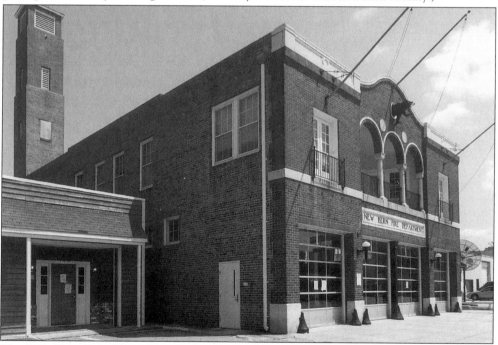

The New Bern Fire Station was built in 1927 for two fire fighting companies—the Button Company and the Atlantic Company. The symbol of New Bern—the bear—is poised in the upper center of the building. The copper bear was once on the city hall but was moved to the brick fire station in 1935. The two-story building now sits vacant since the department moved down the street to a new building in 2000. (Photograph by Frances Eubanks.)

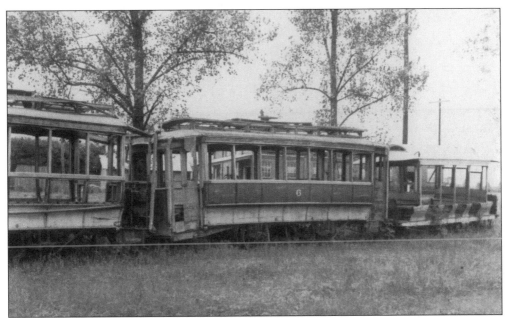

Discontinued streetcars rest in the New Bern-Ghent Street Railway on September 18, 1937. Car #6 has a green roof, a red area below the windows, a cream-colored area below that, and natural oak doors. Closed cars such as these were originally powered by batteries and later electrified for trolley operation in New Bern. The object to the right is a non-electrified trailer (#51), which was designed to be pulled behind the cars. (Photography by H.T. Crittenden, from the David F. Burnette collection.)

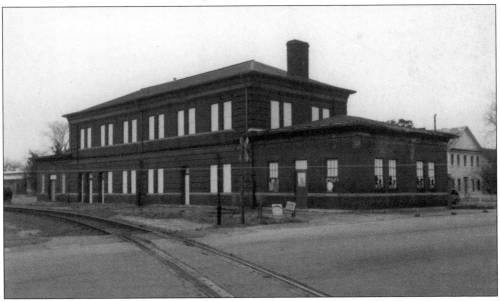

The brick railroad depot was constructed in 1910, replacing a frame building from the mid-1800s. When the Norfolk and Southern Railroad linked New Bern to Norfolk, Virginia, in 1906, New Bern became a railroad hub and a new facility was constructed. Today the old two-story building is being restored by the New Bern Preservation Foundation. (Photograph by Frances Eubanks.)

The United States Post Office was built in the 1930s as part of the Work Projects Administration program established during the Depression. This post office is still in use. (Photograph by Frances Eubanks.)

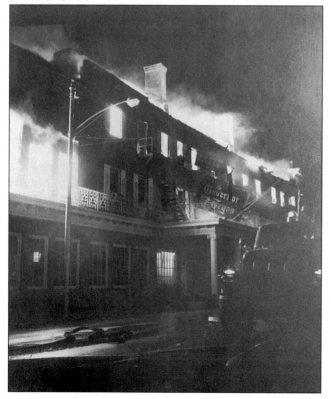

The Governor Tryon Hotel (see page 11), which began life as merchant offices and became the Gaston Hotel in the 1850s, served as a hotel for over 100 years. It was renamed the Governor Tryon Hotel, in honor of the first North Carolina Royal Governor. It was completely destroyed by fire on November 2, 1965. (Courtesy North Carolina Department of Archives and History.)

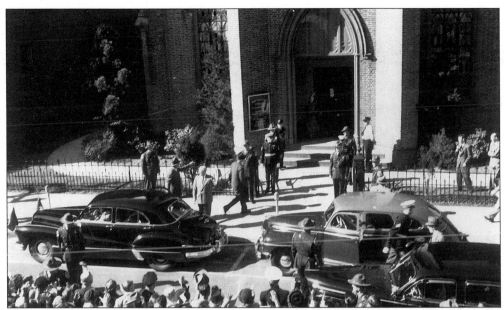

President Harry Truman visited New Bern on November 7, 1948 while en route to his vacation house in Key West, Florida. Making good on a promise to Rev. Thomas Fryer to attend his church—First Baptist—President Truman landed at Cherry Point Marine Corps Air Station, motorcaded to New Bern, attended church, and then continued on his journey. (*Raleigh News and Observer* photograph; courtesy North Carolina Department of Archives and History.)

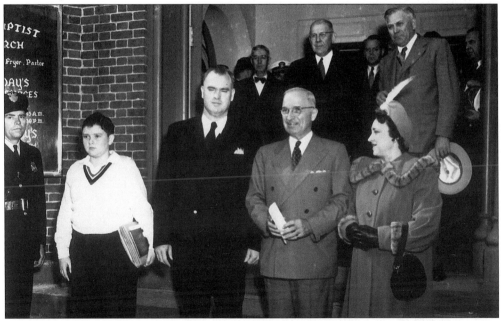

Truman is pictured in front of the First Baptist Church following the service delivered by Rev. Thomas Fryer. Reverend Fryer is shown standing next to the President on the left and Mrs. Fryer is on the right. (*Raleigh News and Observer* photograph; courtesy North Carolina Department of Archives and History.)

During the late 19th century and the beginning of the 20th century many African-American businessmen built homes in an area that was known as Greater Duffyfield. Eventually black businesses were established in the area to serve these residents. As the city grew it moved out and the streetcar extended to what was once farmland. A certain one-and-one-half-story style became popular for structures in the area. (Photograph by Frances Eubanks.)

The Shriner's Sudan Temple, constructed in 1956, stands on Broad Street on the site of one of New Bern's historic old homes. (Photograph by Frances Eubanks.)

Three

JAMES CITY

After Union troops occupied New Bern in 1862, thousands of slaves were freed by making their way behind Federal lines. When Rev. Horace James, a chaplain with the 44th Massachusetts Regiment, was appointed superintendent of Negro Affairs, he set up refugee camps for the newly freed people. The camp, located at the confluence of the Neuse and Trent Rivers, was laid out on Bryan family land confiscated by Union troops. It was originally referred to as the Trent River camp. Near the end of the war it was officially named James City in honor of Reverend James. After the war, many people continued to live in the area—they set up a school, established churches, and developed small businesses.

This arrangement did not last long; the federal government returned the land to its original owner. Some citizens remained and paid rent. Many who refused to pay rent moved to adjoining land and "new" James City was begun. Through the years and with the modernization of Craven County, the sale of property gradually encroached on James City property. Ultimately Highway 70 was widened and divided James City, and today, only a few remnants of the old city are still standing.

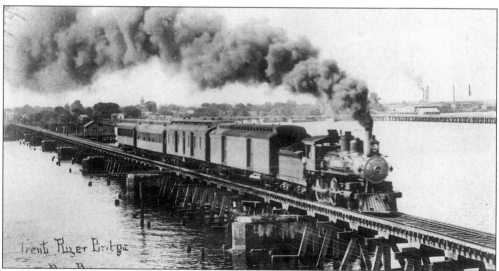

The arrival of rail service to Craven County in 1858 created a great deal of excitement. Train service meant that the rural counties in eastern North Carolina would be united with the Piedmont and that the transportation of people and goods could be expedited. But this was only a temporary boon to farmers and fishermen. The Civil War ended the dream. After the war, the railroad bridge was the only thing that connected the residents of James City to New Bern. The Atlantic and North Carolina is seen crossing the Trent River Bridge, heading toward James City, c. 1910. (Courtesy North Carolina Division of Archives and History.)

Washington Spivey was postmaster general, merchant, farmer, and the leader of the "Committee of Twelve." The committee contested Bryan's right to evict residents of James City from their land—Spivey's store was a meeting place. This photo was taken *c.* 1890. (Courtesy James City Historical Society.)

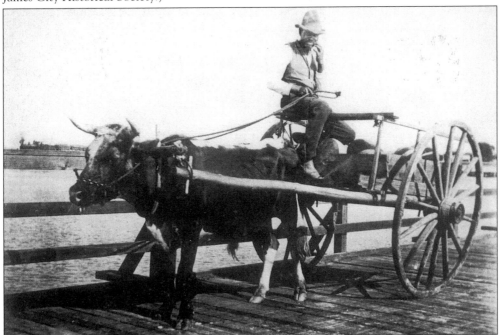

John Perry was a peddler between 1863 and 1900. He is shown here crossing the old wooden Neuse River bridge with his ox-drawn cart. The narrow bridge was constructed in 1898 and carried strict regulations—horse-drawn carts and bicycles had to adhere to strict speed limits. (Courtesy James City Historical Society.)

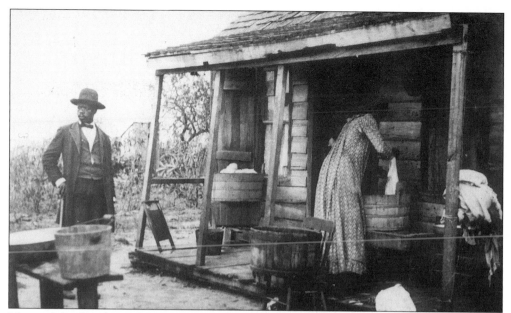

Many of the female residents of James City earned their living as washerwomen. In the early 1900s they walked across the old bridge and picked up dirty clothing from residents in New Bern. They returned home to wash, dry, and fold the clothing, and then again endure the long walk back to New Bern to deliver the clean clothes and receive a small amount of money for the service rendered. (Courtesy James City Historical Society.)

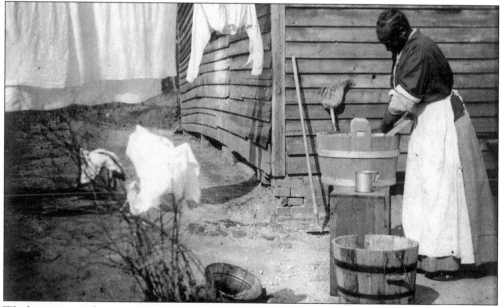

Working as a washerwoman was grueling, day in and day out, year in and year out. Many elderly citizens of James City still remember what it was like working their fingers to the bone at this difficult task. Without the convenience of a washing machine or dryer, washerwomen cleaned everything by hand power on a scrub board. Most of the clothing was boiled in a 50-pound lard can. The only means of drying laundry was by hanging it outdoors on a clothesline and sometimes over a nearby bush. (Courtesy James City Historical Society.)

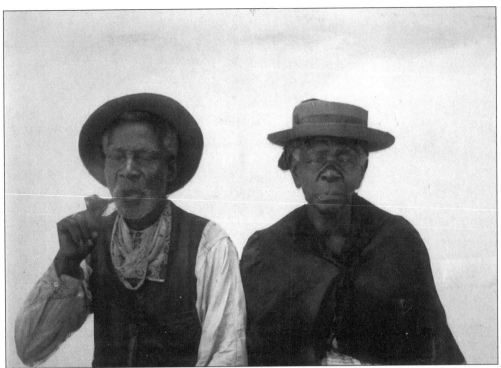

Jesse Brooks is pictured here with his wife at the turn of the 20th century. They were residents of James City. (Courtesy James City Historical Society.)

These two gentlemen look dapper in their uniforms. They are believed to be railroad conductors in New Bern, although there was a railroad depot in James City. The trains stopped in James City, connecting the residents to the outside world. (Courtesy James City Historical Society.)

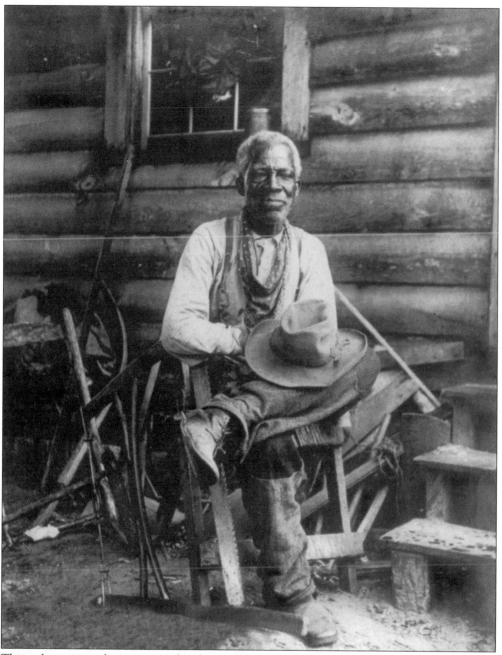

This unknown gentleman is posed in front of his home in James City. The rustic house was not uncommon in the area in the late 1800s and early 1900s; however, there were also many fine homes built in that period. (Courtesy James City Historical Society.)

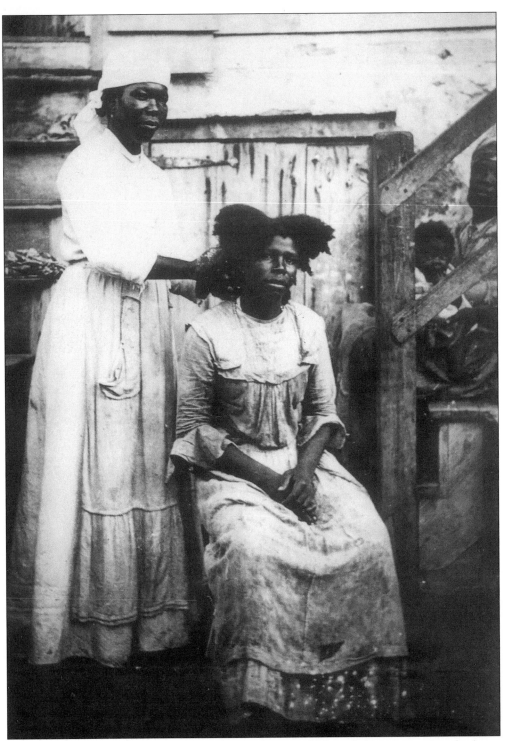

Home styling was the first hair-styling salon "in business." These ladies are creating the latest styles and carrying on a social tradition while talking with their neighbors through the back fence. (Courtesy James City Historical Society.)

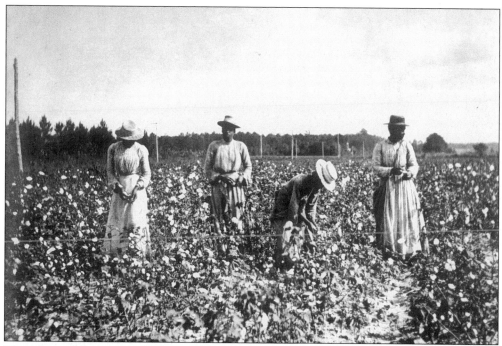

The labor of the cotton field provided jobs for the African-American residents of Craven County well past the days of slavery. As long as cotton was "king" there was a great need for labor to pick the cotton each summer. (Courtesy James City Historical Society.)

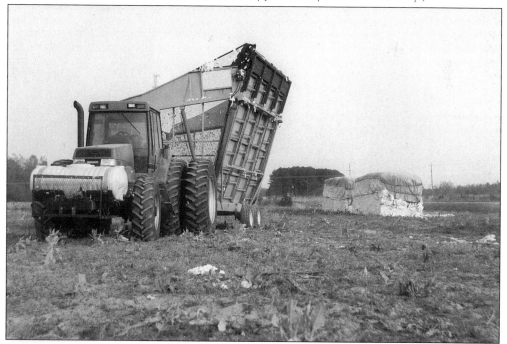

Cotton is still grown in Craven County, though today there is far less human labor involved. Large bales are created right in the field using modern machinery. (Photograph by Frances Eubanks.)

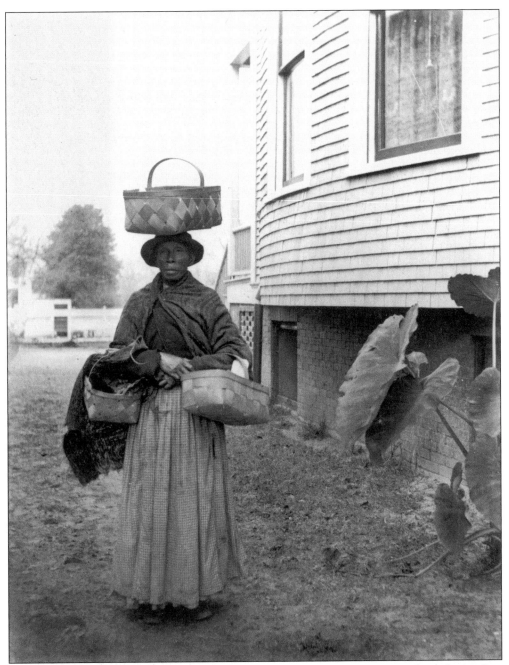

Ladies with baskets on their heads and bundles of clothing were a common sight in James City and New Bern. Current residents recall ladies holding additional baskets in both hands and still managing one on their heads. Many of the washerwomen transported laundry back and forth from their homes to the homes of their patrons. Ladies also peddled goods in this manner. (Courtesy James City Historical Society.)

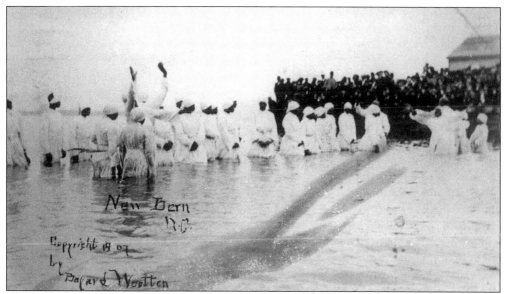

Baptism in the Neuse River in the early 1900s attracted both black and white onlookers who gathered to witness the ritual. In early history, African Americans were baptized in the white churches, mostly the Baptist and Methodist churches, and worshiped alongside the white members of these congregations. These churches were the most active in preaching to members of the African-American community and were adamantly opposed to slavery. In the early 1800s, a movement began in the North to segregate the races during church services, and as the century progressed, new denominations sprang up to serve African Americans (see page 34). (1904 photograph by Bayard Wootten; courtesy James City Historical Society.)

This scene of the old baptism spot is in the new James City area. It is a site of great beauty and holds many fond memories for James City residents. Agnes Bizzell-Colden relates that families came by busloads in the 1950s and 1960s to swim at the "beach" here. The property owner constructed a large concrete building for promoting entertainment, and Tina Turner appeared there when she was performing on the "Chitlin' Circuit." Today the site is a peaceful place on the river perfect for quiet contemplation. (Photograph by Frances Eubanks.)

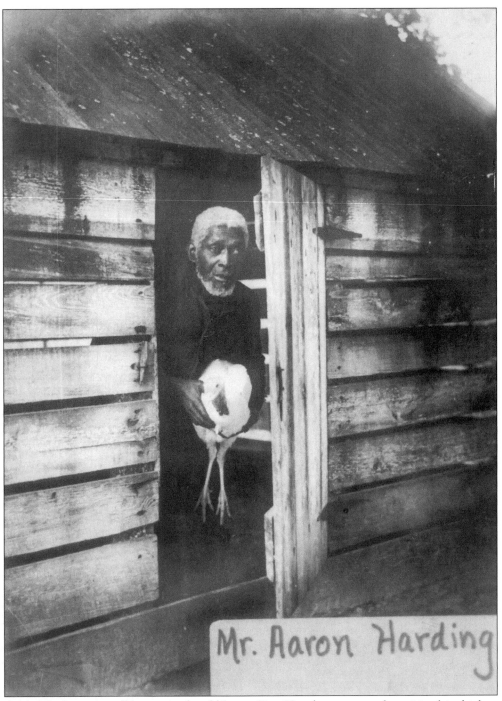

Mr. Aaron Harding

Aaron Harding was well known in the old James City. Here he appears to be exiting his chicken house. (Courtesy James City Historical Society.)

Agnes Bizzell-Colden, a founder of the James City Preservation Society, actively supports the present residents of the James City and preserves its past. A slave cabin and a cemetery are all that is left of the pre-Civil War African-American history of the area. The organization is raising funds to save the old slave cabin, one of the last remnants of the unique history of the area. (Photograph by Frances Eubanks.)

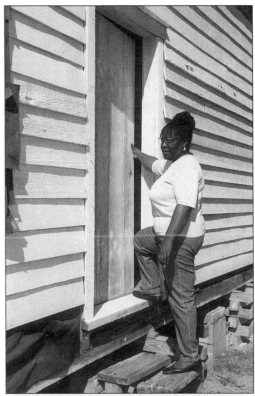

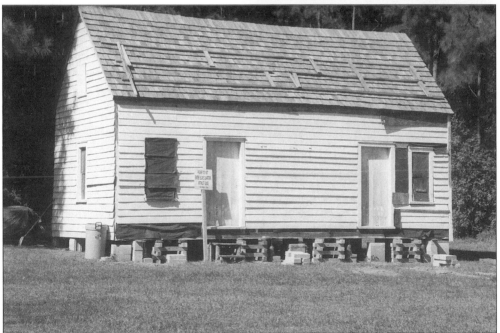

The Crockett-Miller slave quarters were once located outside of New Bern on farmland, and this cabin has been moved near the original location of the Clermont Plantation. Funds are being raised to restore the cabin. (Photograph by Frances Eubanks.)

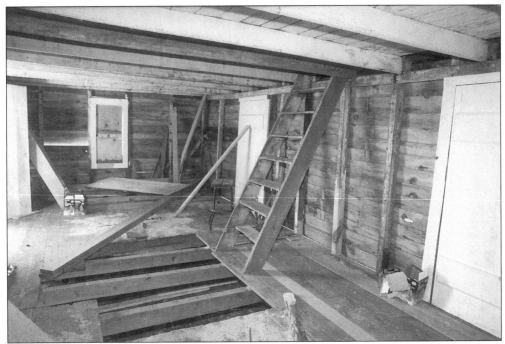

The interior of the slave cabin is being restored to its pre–Civil War appearance. Ten to twelve slaves shared an open, one-room cabin and loft. (Photograph by Frances Eubanks.)

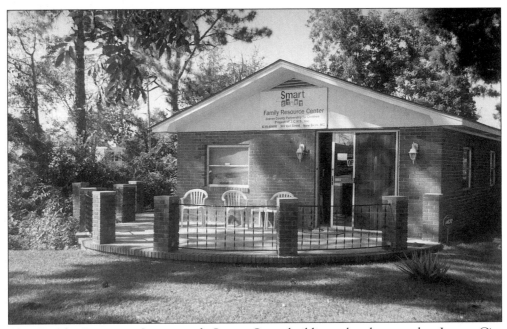

The Family Resource Center and Smart Start building also houses the James City Preservation Society. The structure is located on the Neuse River, near the site of Confederate Fort Lane. The original trenches are on the left, hidden by trees and bushes. (Photograph by Frances Eubanks.)

Agnes Bizzell-Colden's house in the new James City was built in 1913. The hedges in front of the historical structure were brought from the old James City as small cuttings by Linwood Colden, who cultivated them into hedges that he used as a kind of fencing. The rare Seven Sisters rose bush to the left of the house was also brought from old James City and carefully tended throughout the years. (Photograph by Frances Eubanks.)

There are about 20 finely constructed and yet unpretentious homes in the new James City. Most were built between 1890 and 1930, which was an important period of development for the area. (Photograph by Frances Eubanks.)

James City residents are proud of the history of their area. The preservation of the fine old homes here is an ongoing process. (Photograph by Frances Eubanks.)

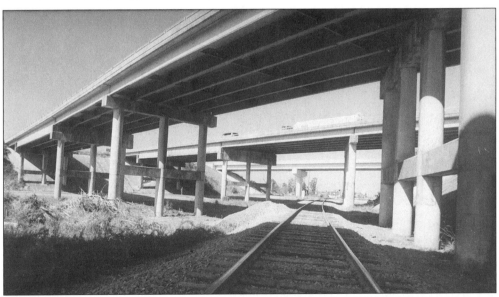

Bridge and road construction enhances the progress and growth of Craven County; yet, such progress also presents a "battle" for the residents of James City. Improvements to Highway 70 that date back to the 1940s have gradually cut James City in half, and the community is now forever divided by a four-lane highway. The construction of the new bridge over the Neuse River in 2000 has further claimed properties in the area for highway exits. Despite the fascinating concrete geometrical layering most of the residents wish the progress could have taken place elsewhere. (Photograph by Frances Eubanks.)

Mount Shiloh Missionary Baptist Church was founded by Rev. Hurley Grimes in 1866 for a congregation that was established in the old James City and later moved to the new James City. The current church building was constructed in 1924 and remains one of the most important landmarks in James City. (Photograph by Frances Eubanks.)

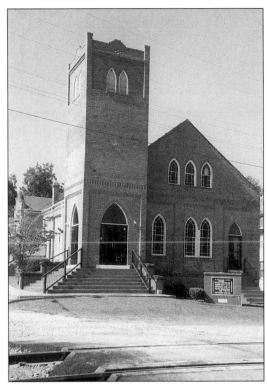

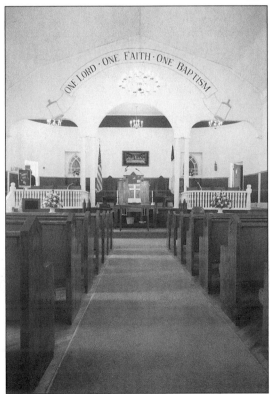

The interior of the Mount Shiloh Missionary Baptist Church is well appointed and elegant in beautiful blue tones. The church is loved and appreciated by its members, and all who enter the sanctuary are touched by its grace. (Photograph by Frances Eubanks.)

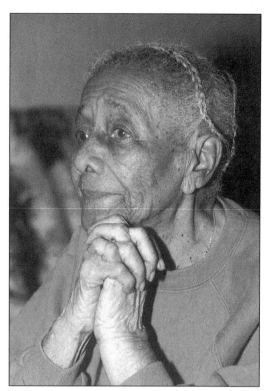

Mrs. Sadie Hill is 92 years old and shared stories of her long life in James City. She and her mother and grandmother were hard-working washerwomen from the late 1800s to the early 1900s. She is a lifelong member of Mount Shiloh Missionary Baptist Church and recalled attending the church when there was no glass in the windows, only yellow cotton curtains. (Photograph by Frances Eubanks.)

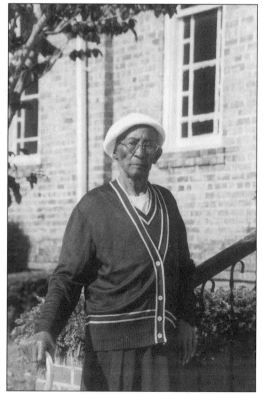

Mrs. Sophia Worrel Lewis was raised in West Virginia but moved with her husband to James City in the 1930s to be near her in-laws. The couple settled in the community and joined Mount Shiloh Church. Mrs. Lewis has been a member ever since and her memories of the church and the James City area are sharp. She still takes her place in "her pew" in church on Sundays. (Photograph by Frances Eubanks.)

Four

THE COUNTY

Most of Craven County remains fields and farms, and the area has always been known for agricultural products and timbering. Prior to the Civil War and until the early 1900s, turpentine and other naval stores were important to Craven County and were large industries. Many small, unincorporated towns and settlements grew up with agriculture as their center, while others grew up as railroad villages. They have names like Fort Barnwell, Croatan, Bellair, Jasper, Thurman, Dover, Rhems, and Havelock. Other than New Bern, the only other incorporated town in the county was Vanceboro.

In the earliest years, poor roads forced residents to rely on water transportation. As late as 1900 much effort and money was spent on river and canal improvements to expedite the flow of goods and passengers. Officials and citizens felt that road improvements were secondary to improvements of the railroad and waterways.

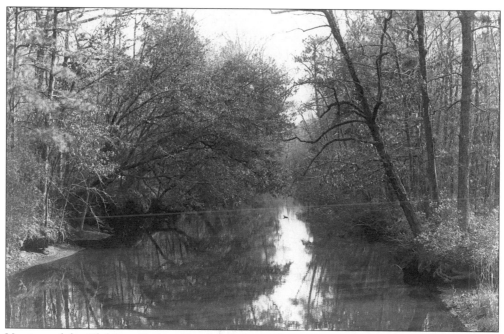

Vestiges of the Clubfoot Harlow Canal, which was begun in 1814, are still visible today. The dream of a series of canals wide and deep enough to connect the Neuse River to the Pamlico Sound continued to exist through the 1800s. In the 1870s the canal was a toll way and was used by steamers making their way into New Bern. This 1981 photograph shows that the original towpath has been overgrown. (Courtesy North Carolina Division of Archives and History.)

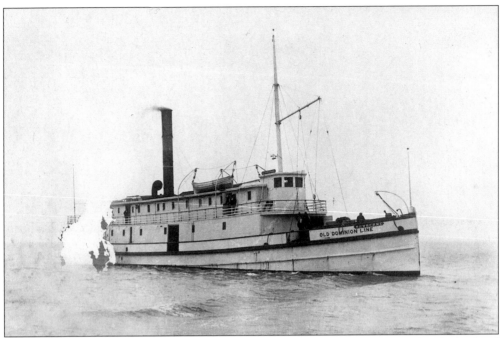

This Old Dominion Line Steamer, c. 1910, was typical of the large steamers that docked and hauled goods from New Bern up and down the Neuse River and on to ports in Beaufort and Morehead City. At the turn of the century these shallow draft boats were the main mode of transportation for travelers and for the delivery of products to market, and replaced sail power. (Courtesy North Carolina Division of Archives and History.)

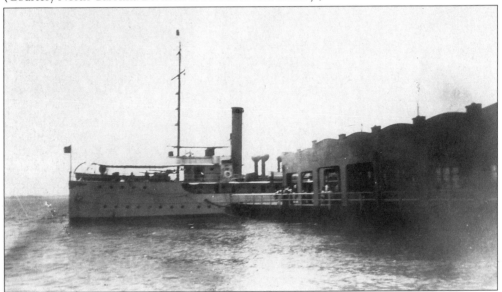

The Coast Guard cutter *Pamlico* was a fixture on the New Bern waterfront and a familiar vessel plying the Neuse River for over 35 years. The cutter was built in 1907 and stationed at New Bern until after World War II when she was decommissioned. Its duties included patrolling the waterways of eastern North Carolina. (Courtesy North Carolina Division of Archives and History.)

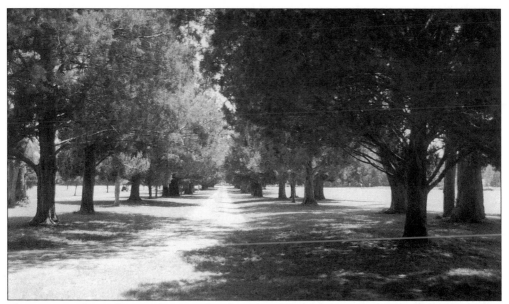

The carriage lane shown above is lined with ancient cedar trees and still leads to the magnificent main plantation house known as Bellair. The plantation was constructed on farmland acquired in the 1700s by Jonathon Swift from the Lords Proprietors and fronts on the old post road to Washington, North Carolina. In 1838 the plantation was sold to John H. Richardson, and the property is in the hands of his heir, Graham Richardson. (Photograph by Frances Eubanks.)

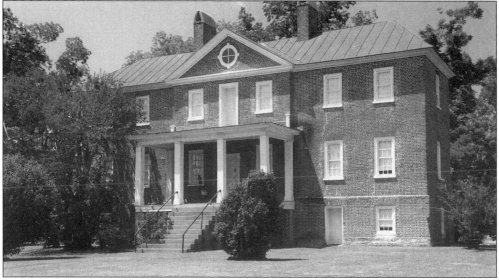

The Bellair Plantation house was built in the late 1770s and is the last brick 18th-century plantation house still standing in North Carolina. The proportions of the house are of great interest to historians. Constructed of hand-made brick with a marl (shell rock) foundation, the home rises three stories. It is 40 feet high, 70 feet long, and only 20 feet wide. Though many such structures were destroyed by the Union forces during the Civil War, Gen. Ambrose E. Burnside issued a "safeguard" to protect Bellair. The order still hangs on the wall. (Photograph by Frances Eubanks.)

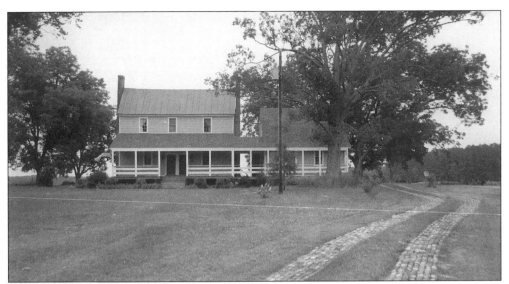

Chapman's Chapel was a crossroads community in Craven County in the late 1700s, when the Chapman family settled there and constructed homes and a chapel. There is no indication of any commercial establishments in the immediate area; however, farmers could have reached Vanceboro easily, as well as Washington and New Bern. The community continues to support beautiful farms but is only identifiable today as Chapman's Chapel because of the restoration of the Chapman brothers' original planter's houses. Pictured above is the Alfred Chapman House, 1839–1841. (Photograph by Frances Eubanks.)

Simple frame farmhouses continue to dot the countryside throughout Craven County. Unfortunately, most of them have deteriorated beyond restoration. (Courtesy North Carolina Division of Archives and History.)

Church Chapman's house sits up on a knoll surrounded by farmland. It has been totally restored to its former glory. (Photograph by Frances Eubanks.)

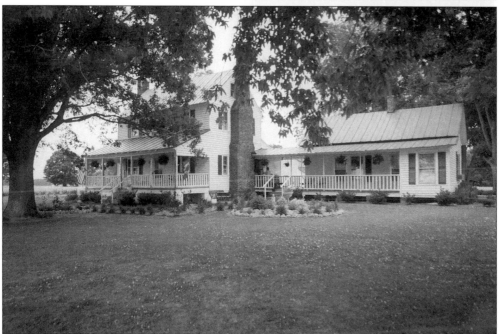

The Chapman House has landscaped yards with beautiful old trees. The detail of the house includes twin chimneys constructed in a Flemish bondwork pattern of handmade brick. Both Chapman houses are privately owned. (Photograph by Frances Eubanks.)

Tobacco was once the most important crop in Craven County, and tobacco barns once dotted most of the farmland. Today the barns are scarce and are indeed monuments to a time gone by. (Photograph by Frances Eubanks.)

Much of the land in the county is farmland, and at one time there were extensive truck farms. Today farms still grow vegetables, cotton, and tobacco. Some of the products are consumed locally, but many are shipped to other markets throughout the East. (Photograph by Frances Eubanks.)

Vanceboro was named after Gov. Zebulon Vance visited the small community. He gave a rousing oration that so impressed the citizens they voted to name their small town Vanceboro in his honor. There are several old houses of interest in this community, and the Victorian Inn Bed and Breakfast (pictured here) was built by Octavius McLawhorn in 1907. (Photograph by Frances Eubanks.)

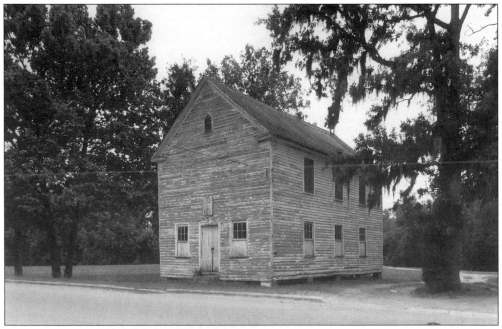

Vanceboro has many old structures that have been spared demolition. This is Masonic Sheba Lodge #94, which was built in 1905 and served an African-American Masonic group for many years. (Photograph by Frances Eubanks.)

Most railroad communities had a depot, a church, a general store, and sometimes a school. The church was always the heartbeat of the community, providing refuge, religious instruction, and a place for social interaction. This beautiful church near Highway 70 in Croatan displays the charm of a 20th-century meeting house with its large portico and soaring steeple. (Photograph by Frances Eubanks.)

The Croatan Presbyterian Church, located in the Croatan area on Highway 70, was built in 1884. It was begun as a very simple structure, and as the community grew, the church gained a front portico and a bell tower. It has been enlarged on several occasions since and is known for its beautiful woodwork both inside and out. (Photograph by Frances Eubanks.)

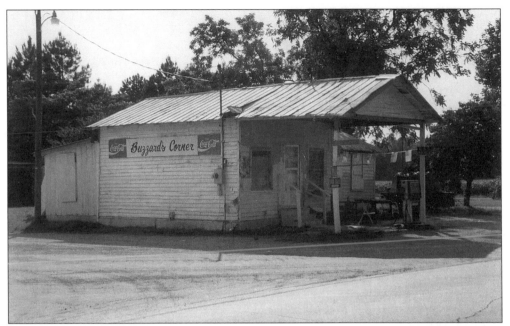

Many small hamlets in Craven County survived thanks, in part, to the establishment of churches, schools, and general stores such as Buzzard's, which still stands in Cove City. These stores sustained the families in these communities between their "big" trips into town. (Photograph by Frances Eubanks.)

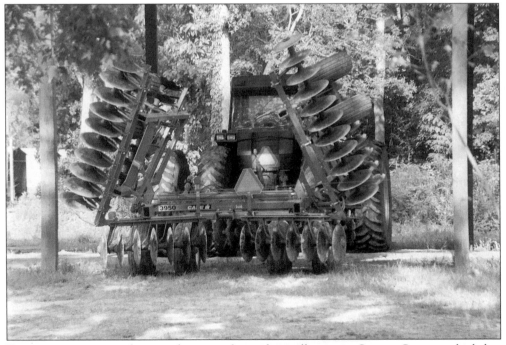

Farm equipment is evident on the many farms that still exist in Craven County, which has always been known as one of the "bread baskets" of North Carolina. Unlike the early years, the Craven farms are now highly mechanized. (Photograph by Frances Eubanks.)

The Nathan Whitford House was located outside of Vanceboro. Local Vanceboro historian Janice Cannon was the granddaughter of Nathan Whitford; her mother grew up in this house. Janice married Octavius McLawhorn (see page 71). When the property was sold the house was demolished.

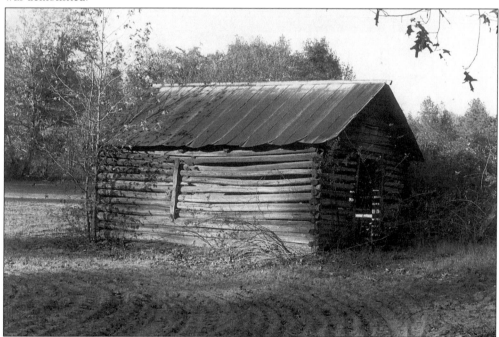

Old barns and outbuildings are all that is left of early hand construction, and many of these have been left to decay or have been replaced with modern structures. Outbuildings were essential to the storage of items necessary to run a farm. (Courtesy North Carolina Division of Archives and History.)

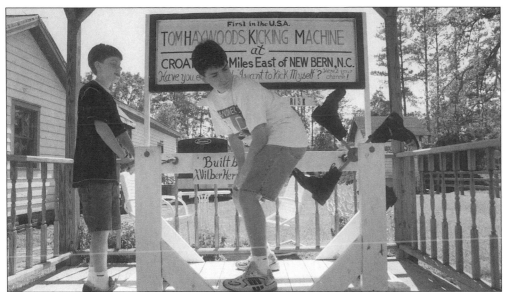

Tom Haywood Store was built in the late 1800s and still stands along side Highway 70 in the Croatan area of Craven County. Even though the building retains its original look, it is no longer a general store but an antique shop. The store is most famous for its "self-kicking machine," which was created in 1937 by Tom Haywood, himself. The machine consists of a hand-operated crank that is connected to a "kicker" that is adorned with two shoes. To be kicked, the "kickee" simply had to stand in the mechanism and bend over. The person could kick himself by turning the crank. In the photograph above, Brian Salsi turns the crank to kick his brother Bo Salsi. This structure is a copy of the original machine, which is in the North Carolina Museum of History in Raleigh. (Photograph by Frances Eubanks.)

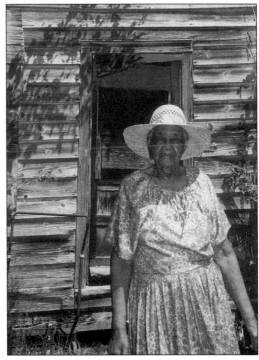

As a girl, Mrs. Ethel Bennett walked two miles—to and from school—from her home in the Hickman Hill section near Havelock. The school is still standing and the Havelock Preservation Society has taken steps to preserve the historical structure. (Photograph by Frances Eubanks.)

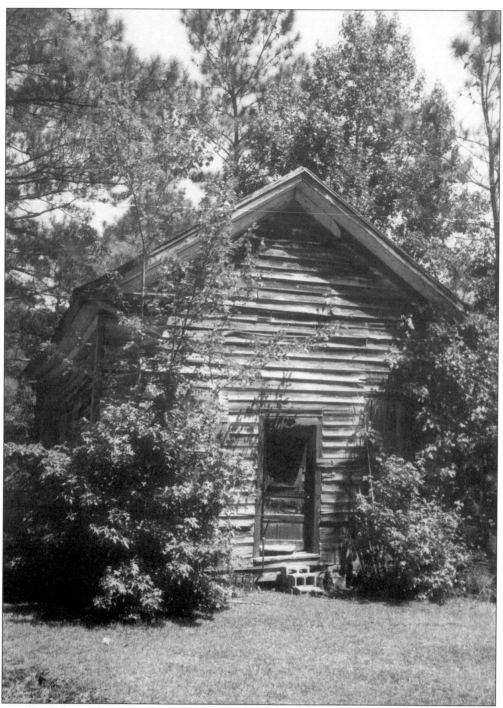

Mrs. Ethel Bennett now lives on the property where the one-room frame schoolhouse of her childhood is located. It was one of the first schools for African-American children in Craven County. Twelve to fifteen students regularly attended classes. Mrs. Bennett shared her memories of her teachers, Mrs. Cox and Mrs. McDonald, who taught multiple grades in this small building. (Photograph by Frances Eubanks.)

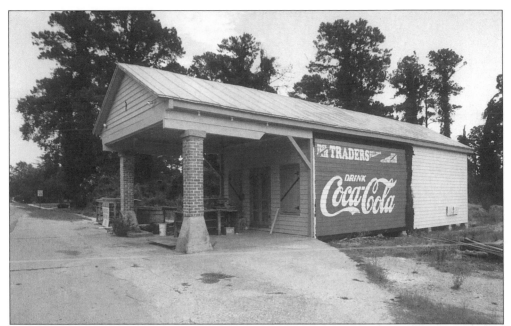

Trader's Store, once "the" landmark in Havelock, is now under renovation as part of a preservation project of the Havelock Historical Society. Trader's also served as the post office and sold foodstuffs, auto parts, horse liniment, and pig feed. J.J. Trader and his son Hugh traded stories around the pot-bellied stove. Many people remember the heyday of Trader's and the many sportsmen who frequented the establishment for a can of Vienna sausages and saltines. (Photograph by Frances Eubanks.)

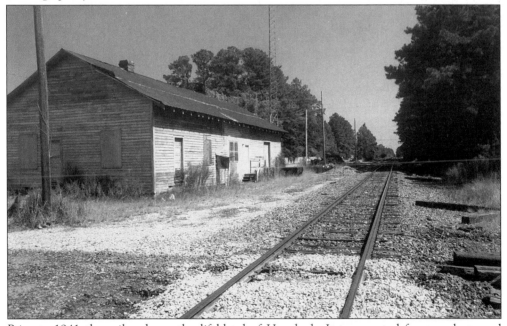

Prior to 1941 the railroad was the lifeblood of Havelock. It transported farm products and allowed residents to stay in touch with the rest of the world. The Atlantic and East Coast freight station still stands beside the track. (Photograph by Frances Eubanks.)

Between 1858 and the 1930s the railroad was all that connected Craven County residents to the outside world. There were only two hand-crank telephones in the area: one was at Trader's and the other at the train station, which was located near this crossing by the store. The phone at the train station was meant only for official railroad use, but it did give local residents a feeling of security. (Photograph by Frances Eubanks.)

Canals interwove the streams, rivers, lakes, swamps, and pocosin over the thousands of acres of land within Camp Bryan and throughout the river basins, providing easy access to hunters and fishermen in this area of Craven County. (Courtesy G.A. Nicoll Photo Album, New Bern-Craven County Photographic Archive, New Bern-Craven County Public Library.)

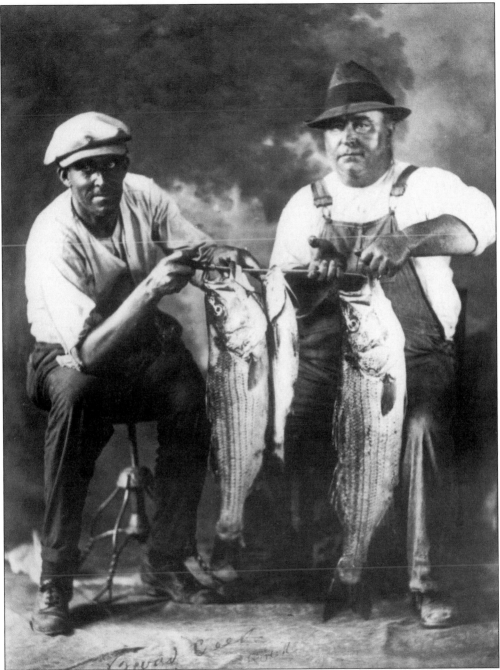

A Confederate officer, Maj. James Augustus Bryan, inherited 57,484 acres in Craven and Jones Counties that included five lakes: Lake Ellis, Little Lake, Long Lake, Great Lake, and Catfish Lake. It was also a valuable source of timber and much of it was farmland. In 1891 the property was sold to be a game preserve. A private club was established and the area enjoyed the reputation as a "hunter's and fisherman's paradise." These two gentlemen are posed, c. 1920, with their catch of two striped bass. (Courtesy G.A. Nicoll Photo Album, New Bern-Craven County Photographic Archive, New Bern-Craven County Public Library.)

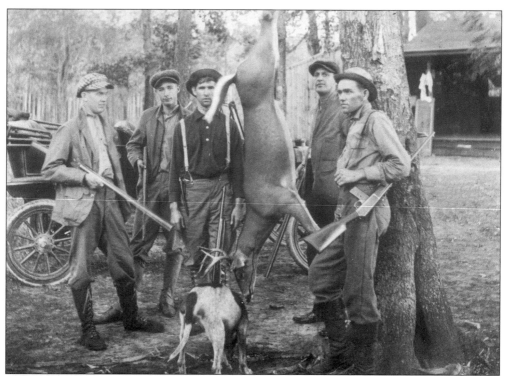

These dogs and men take a break after the hunt and pose casually with their "trophy" in this September 1914 photograph. (Courtesy G.A. Nicoll Photo Album, New Bern-Craven County Photographic Archive, New Bern-Craven County Public Library.)

The well-dressed gentlemen in this c. 1909 image are, from left to right, N.C. Hughes, William Denny, and G.B. Waters. The men do not look as through they joined the hunt despite the fact that Mr. Waters is holding a rifle. (Courtesy G.A. Nicoll Photo Album, New Bern-Craven County Photographic Archive, New Bern-Craven County Public Library.)

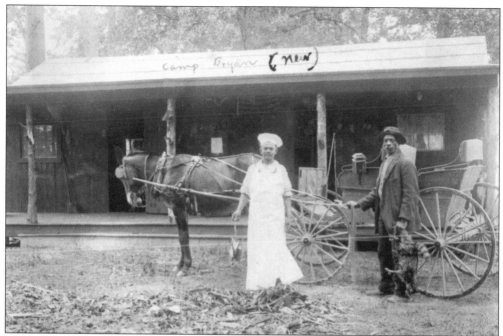

Dave, the cook at the new Camp Bryan, is pictured here with Ben, the caretaker, on January 15, 1911. (Courtesy G.A. Nicoll Photo Album, New Bern-Craven County Photographic Archive, New Bern-Craven County Public Library.)

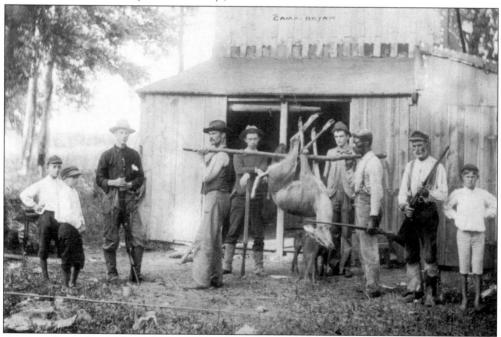

The buck was killed by George A. Nicoll and the doe by Ed Meadows at Camp Bryan. Pictured from left to right are W.W. Clark, Dinn ?, Dan ?, Ed Hancock, and Wade Meadows. (Courtesy G.A. Nicoll Photo Album, New Bern-Craven County Photographic Archive, New Bern-Craven County Public Library.)

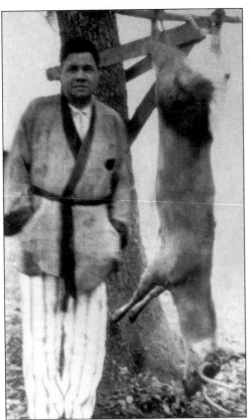

Babe Ruth rests against a tree at Camp Bryan, and it is supposed that he is posing with a deer that he shot earlier in the day. (Courtesy G.A. Nicoll Photo Album, New Bern-Craven County Photographic Archive, New Bern-Craven County Public Library.)

Not satisfied with 5 deer, 31 ducks, 3 turkeys, 2 geese, and several doves bagged by his party on their hunting trip in Eastern North Carolina, Babe Ruth takes a parting shot at a deer in the woods around Camp Bryan. Many ducks may be seen hanging on the porch. With the Bambino are John Kieran, sports writer of New York, and Frank Stevens, hot-dog king of New York. Although the Babe was in training and could not imbibe himself, the fruit jars at the left denote that they were hospitable hosts, keeping the famed CCC (Craven County Corn) for their callers. (Caption by Gertrude Carraway; photo and caption courtesy G.A. Nicoll Photo Album, New Bern-Craven County Photographic Archive, New Bern-Craven County Public Library.)

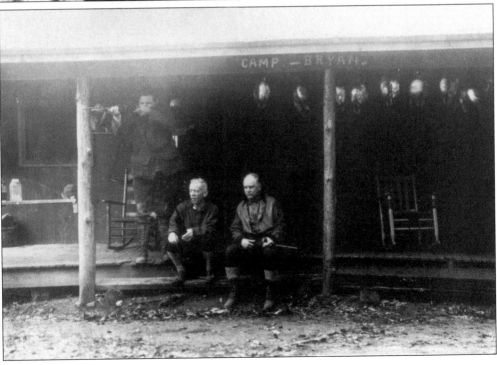

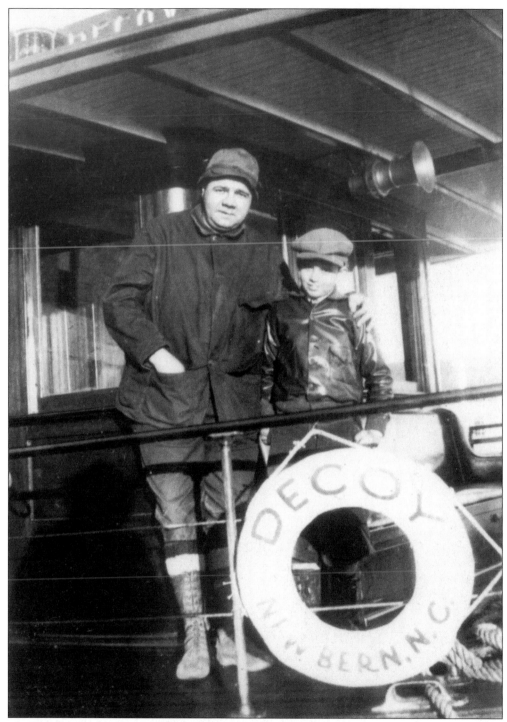

The Babe is posed with young Bill Blades on the stern of the *Decoy*, the boat that took hundreds of sportsmen to their destinations in Craven and Carteret Counties. (Courtesy G.A. Nicoll Photo Album, New Bern-Craven County Photographic Archive, New Bern-Craven County Public Library.)

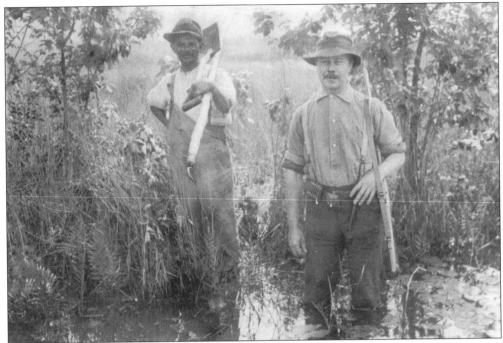

Gator hunters, noted as Dave ? (left) and H.H. Brimley (right), are shown here knee-deep in swamp waters. (Courtesy G.A. Nicoll Photo Album, New Bern-Craven County Photographic Archive, New Bern-Craven County Public Library.)

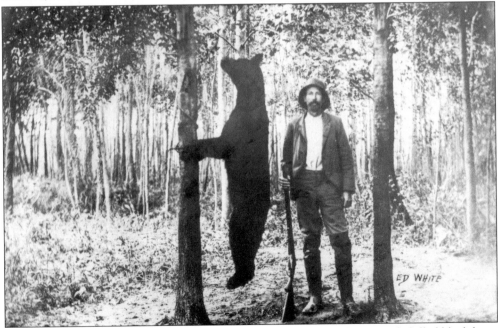

Bear hunter Ed White has his gun in hand as he stands by his trophy, a newly killed black bear. American black bears were once plentiful in Eastern North Carolina, and today there are a number of protected bear habitats. (Courtesy G.A. Nicoll Photo Album, New Bern-Craven County Photographic Archive, New Bern-Craven County Public Library.)

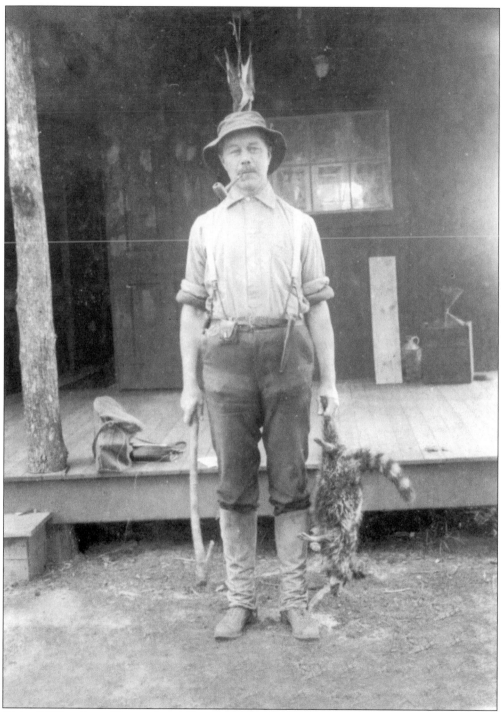

"Brim," "The Coon Hunter," and "Prince of Sportsmen" was H.H. Brimley, a naturalist and the first director of the North Carolina Museum of Natural History. (Courtesy G.A. Nicoll Photo Album, New Bern-Craven County Photographic Archive, New Bern-Craven County Public Library.)

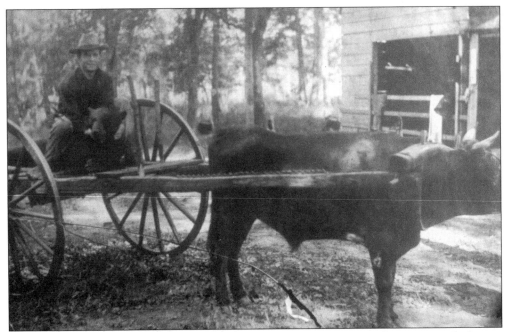

Oxen, known for their strength and endurance, were important for pulling carts and plowing fields. This ox cart hauled many a load of supplies for Camp Bryan sportsmen. Note the bear carcass loaded on the cart bed. (Courtesy G.A. Nicoll Photo Album, New Bern-Craven County Photographic Archive, New Bern-Craven County Public Library.)

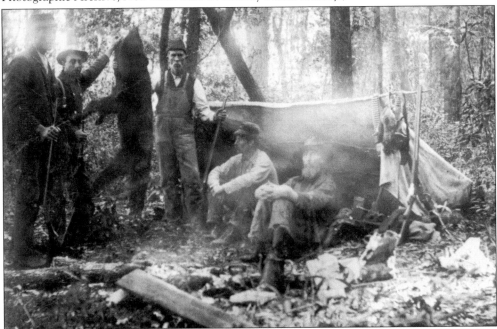

The above photo is entitled "In Camp on the Great Lake—Bear Hunt 1919." There were five lakes within the Camp Bryan area, and for a number of years, bear hunting was an acceptable sport in the area. (Courtesy G.A. Nicoll Photo Album, New Bern-Craven County Photographic Archive, New Bern-Craven County Public Library.)

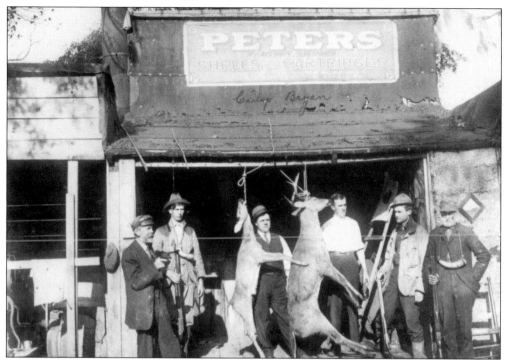

In September 1905 A.B. Nicoll killed the deer that is shown in this photograph. Nicoll was North Carolina's game commissioner and a frequent hunting companion of Babe Ruth. Numerous wealthy Northern sportsmen traveled south each year for the hunting in Craven County. (Courtesy G.A. Nicoll Photo Album, New Bern-Craven County Photographic Archive, New Bern-Craven County Public Library.)

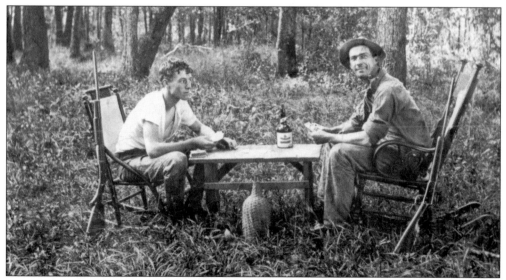

Relaxation and card games at camp were standard diversions. Many businessmen came to Camp Bryan to get away from the stresses of business as much as to take advantage of the great hunting and fishing opportunities. (Courtesy G.A. Nicoll Photo Album, New Bern-Craven County Photographic Archive, New Bern-Craven County Public Library.)

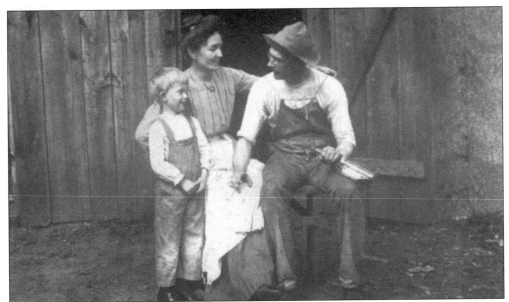

When Camp Bryan was first established it was not considered a proper place for women and children, but in the 1930s the rules were relaxed and families welcomed. By that time many of the members had constructed individual houses at camp and accommodations for more people were available. George Waters and his family are pictured above. (Courtesy G.A. Nicoll Photo Album, New Bern-Craven County Photographic Archive, New Bern-Craven County Public Library.)

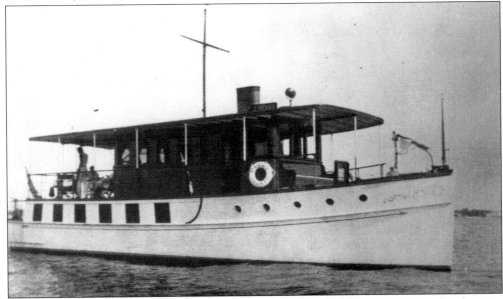

This vessel, the *Decoy*, was owned by Mr. William Benjamin Blades, a real estate developer in New Bern and Morehead City. The son of timberman William Blades, he lived in the beautiful family home built by his father (see page 24). He was known for building the first neighborhood of "spec" houses in the state, and was a founding member of Camp Bryan. Blades used the *Decoy* for pleasure and to take out hunting parties. (Courtesy North Carolina Department of Archives and History.)

Many people from Craven and Carteret Counties remember attending religious and social events in Harlowe. Pictured is a gathering from a baptism, *c.* 1920. (Courtesy Madge Guthrie Private Collection.)

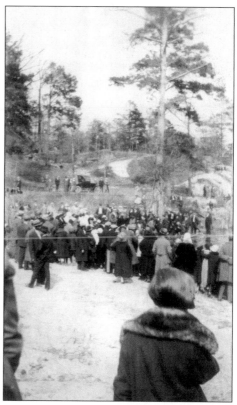

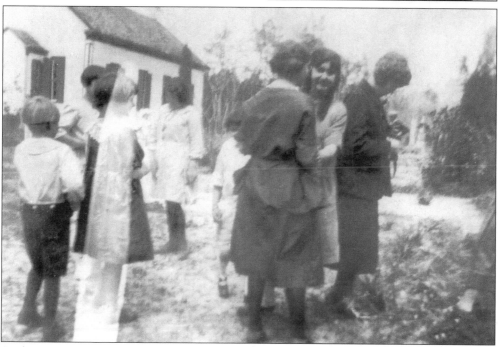

Students and their families are pictured on the grounds of the Harlowe School in 1922. (Courtesy Madge Guthrie Private Collection.)

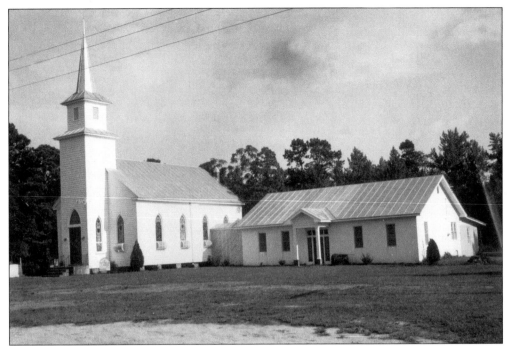

The Harlowe Methodist Church was the center of religious fervor as well as a gathering place for local residents. Churches were often the center of social activity in rural communities. (Courtesy Eubanks/Salsi Private Collection.)

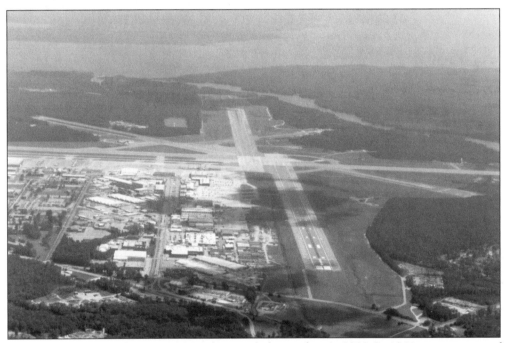

The runway at Cherry Point is seen in this aerial photo taken in 2000. In 1941, construction of the Cherry Point Marine Corps Air Station brought growth and progress to Craven County. (Photograph by Frances Eubanks.)

Five

CHERRY POINT

In 1941 plans were made to expand bases for the Marine Corps. The Committee on Naval Affairs met to consider authorization of a new base in North Carolina near a place called Cherry Point. Land in Craven County was found to be ample in size, accommodating to seaplane and landplane facilities, with miles of coastal area for gunnery practice. The climate was considered mild and there was enough land for unlimited outlying facilities and airfields.

On February 18, 1941, Congress authorized the expenditure of $25 million for the construction of the facilities and in September the first parcel of 7,582.2 acres of land was purchased for $104,869. The base was originally named Cunningham Field, Cherry Point, in honor of 1st. Lt. Alfred A. Cunningham , the first Marine aviator in 1912. On December 1, 1941, it was designated Cherry Point and was so commissioned in 1942. The United States entry into World War II caused the base construction to be expedited, yet the first four runways were not completed until June 8, 1942.

Before the Marine base construction, the Cherry Point community had about 200 residents. Little Witness, Havelock, Harlowe, and Holland were the adjacent rural communities. The residents mostly owned small farms of corn, tobacco, and cotton. In 1940, Havelock had a post office and 24 houses.

The completion of the world's largest Marine Corps air station in 1941 brought stability and prosperity to the county.

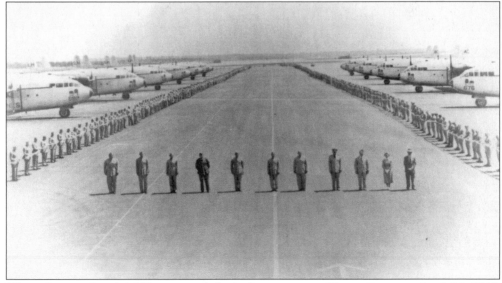

"Short Snorters" and 9,000 personnel flank the runway at Cherry Point on April 16, 1945. (Courtesy the National Archives and the Marine Corps Air Station, Cherry Point.)

This photograph was taken on October 29, 1941, during the construction of Cherry Point. It shows fill at Roosevelt Boulevard and C Street at what was then named Cunningham Field. The new Marine base was begun after Congress authorized construction of the station on February 15, 1941. (Courtesy Marine Corps Air Station, Cherry Point.)

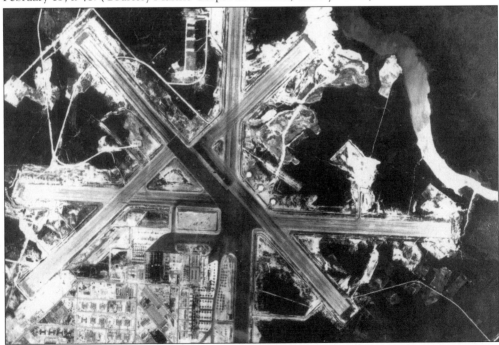

This aerial view shows the runways nearly completed. When Japanese troops bombed Pearl Harbor on December 7, 1941, the construction of the Cherry Point facilities was accelerated. By June 8, 1942, four runways were complete. On December 9, 1941, two platoons of the 14th Marine Provisional Company-New River reported to temporary detached duty as Marine guards. (Courtesy Marine Corps Air Station, Cherry Point.)

In this November 26, 1941 photograph, the asphalt mixing plant and a temporary railroad at Cunningham Field are visible. A short while later the name for the new base was officially declared Cherry Point and the base was commissioned as such on May 20, 1942. (Courtesy Marine Corps Air Station, Cherry Point.)

The barracks area was under construction in November 1941, and the housing conformed to plans for low-cost war housing as set forth by the Bureau of Yards and Docks. The plan provided for 500 dwelling units, which proved too few when war was declared. (Courtesy Marine Corps Air Station, Cherry Point.)

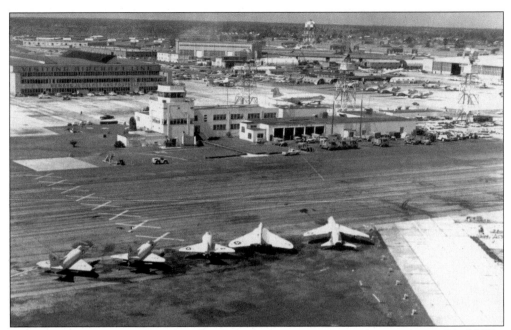

The Marine Corps Air Station has served the nation since its construction during World War II. The photograph above was taken in the 1950s during the Cold War. (Courtesy Marine Corps Air Station, Cherry Point.)

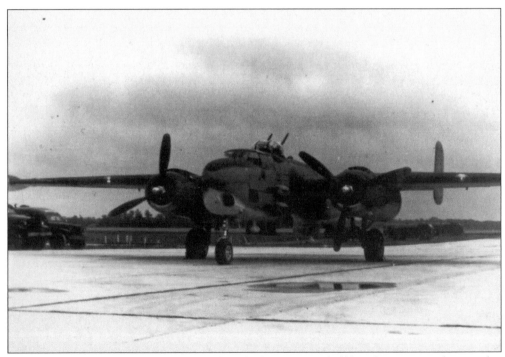

During World War II pilots were trained to fly the B25 Mitchell bomber. During the war this was the largest bomber aircraft able to take off carriers. (Defense Department photograph courtesy of Marine Corps Air Station, Cherry Point.)

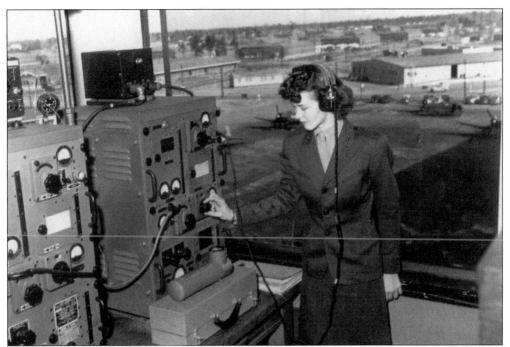

Female Marines did everything at Cherry Point during World War II. There was almost a "wing-size" number of females stationed at the base. A female Marine is shown above working the dials in the radar control tower, and F4 Corsairs can be seen on the tarmac in the background. (Courtesy Marine Corps Air Station, Cherry Point.)

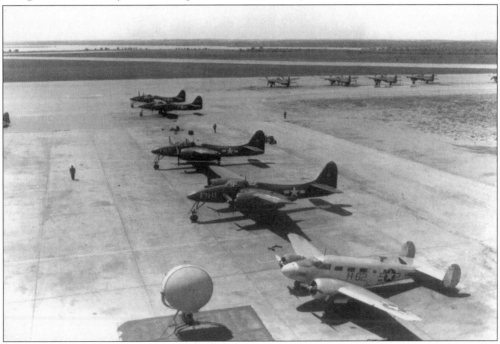

F7F Tigercats and SNB (C-45) are pictured here on a ramp in April 1945. (National Archives photograph courtesy Marine Corp Air Station, Cherry Point.)

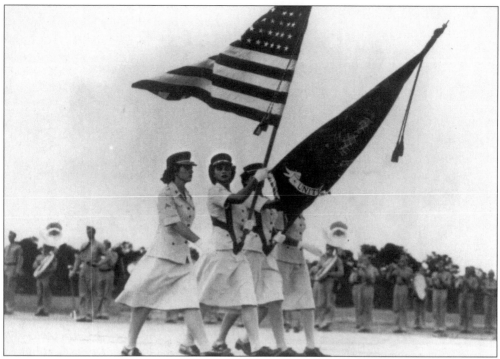

A female Marine color guard is shown here on parade at Cherry Point on September 28, 1945. The 1st Women Reserves arrived on May 29, 1943, with 2nd Lt. Meredith Lynn in charge of 18 women from Hunter College. At first, all of the women were assigned to Aircraft Engineering Squadron 45. (National Archives photograph courtesy Marine Corps Air Station, Cherry Point.)

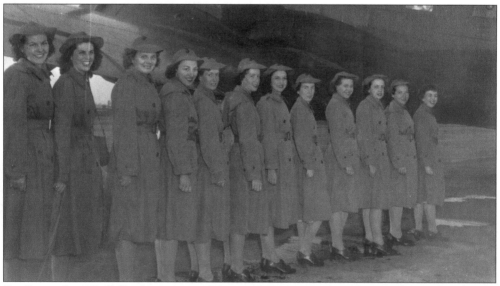

On September 15, 1943, these women Marines R4D prepared to fly to Jacksonville, Florida, from Cherry Point. Many women trained in the Aircraft Engineering Squadron were later transferred to fill positions at other airfields. (National Archives photograph courtesy Marine Corps Air Station, Cherry Point.)

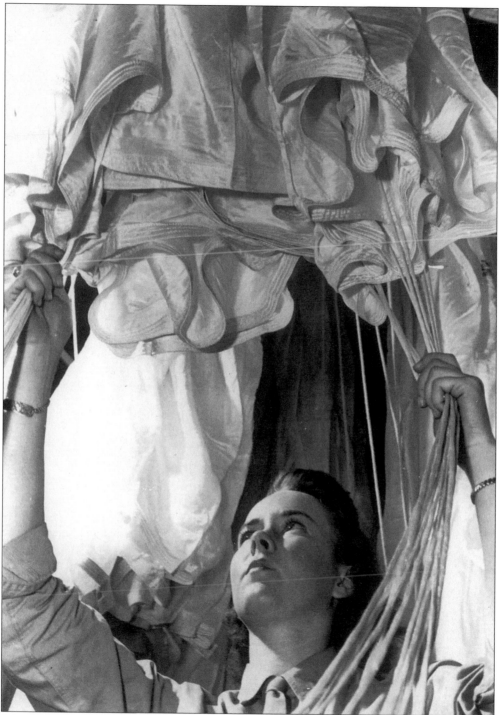

Pilots and paratroopers were trained at the air station. Women were trained to inspect and pack parachutes for the troops. (Courtesy Marine Corps Air Station, Cherry Point.)

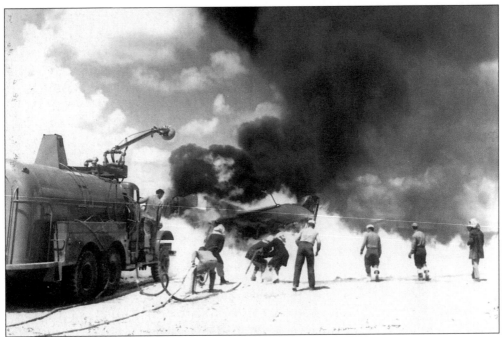

In this April 13, 1945 view, an overhead boom nozzle is brought into play to control and drive fire away from planes at the Marine Corps Air Station, Cherry Point. (National Archives photograph courtesy Marine Corps Air Station, Cherry Point.)

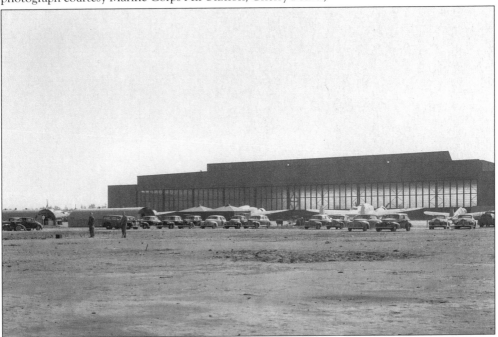

The mammoth task of building Cherry Point involved 7,582.2 acres of land and required the construction of a sawmill and three asphalt plants. Thousands of civilians were employed in the huge project, giving a gigantic boost to the local economy. Pictured above is construction area #1 in 1942. (Courtesy Marine Corps Air Station, Cherry Point.)

Women Marines were trained in the painstaking and important job of aerial mapmaking at the Marine Corps Air Station, Cherry Point. This photograph was taken in May 1944. (Courtesy Marine Corps Air Station, Cherry Point.)

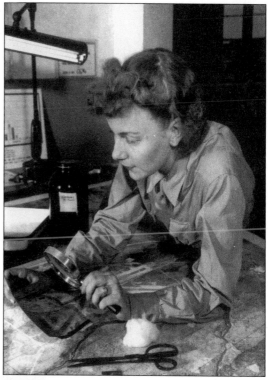

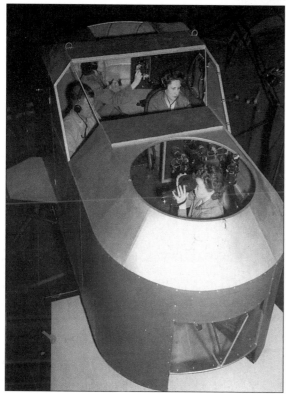

Women Reserves are shown here in a crew celestial navigation trainer in 1944. Crewmembers, from left to right, Capt. B.B. Tucker, Sgt. Rita Schuare, Pfc. Jeanette Walker, and Pfc. Jane L. Russell are in the fuselage of the trainer with the celestial dome in the background. (Defense Department photograph courtesy Marine Corps Air Station, Cherry Point.)

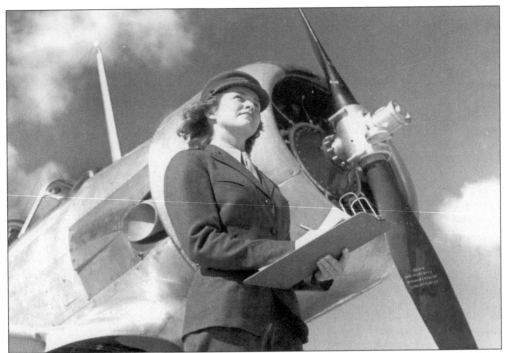

Women Marines took over hundreds of jobs to release their male counterparts for combat duty. This young woman learns to check planes in flight at the airfield. The field developed a special landing sequence, and any breakdown led to unidentified planes being easily sighted by spotters. The unique design of the runways was conducive to large-scale operations. (Courtesy Marine Corps Air Station, Cherry Point.)

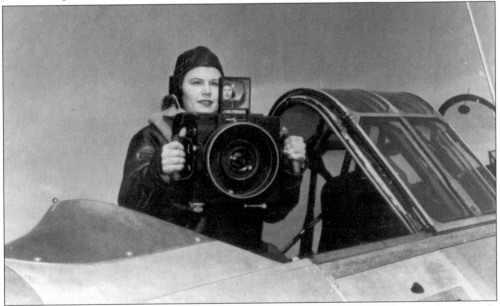

Women Marines also became aerial photographers at Cherry Point. This photograph was made in November 1944. The size of the camera is amazing. (Courtesy Marine Corps Air Station, Cherry Point.)

The Harrier aircraft pictured above features a dual cockpit and is a designated trainer. The mission of the AV-8B Harrier is to attack and destroy surface targets day or night. Cherry Point is considered one of the best all-weather jet bases in the world. (Photograph by Frances Eubanks.)

The AV-8B Harrier II's mission is air support. It can conduct combat air patrol, armed escort missions, and offensive missions against enemy ground-to-air defenses. The Harrier's unique feature is its tactical mobility—allowing it to take off and land vertically. (Photograph by Frances Eubanks.)

The KC-130 Hercules is a versatile multi-task transport. They are used mostly for aerial refueling. The transport squadron at Cherry Point Marine Corps Air Station provides all the in-flight refueling the Wing needs. The Hercules has enough fuel capacity to refuel two planes simultaneously. It can also perform the task of troop and cargo delivery and can land in unimproved areas within war zones. (Photograph by Frances Eubanks.)

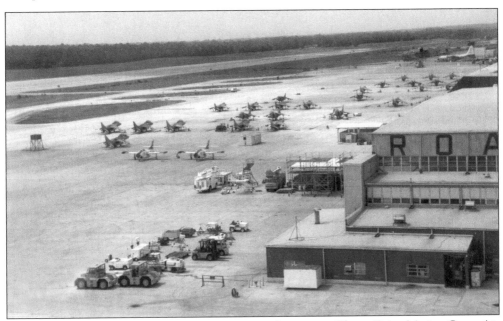

AV-8B Harrier IIs and Harrier trainers are seen on the tarmac. Cherry Point Marine Corps Air Station is home to the Marine Wing Support 27 which provides all aviation ground support. Cherry Point is an alternate emergency landing sight for NASA space shuttles. (Photography by Frances Eubanks.)

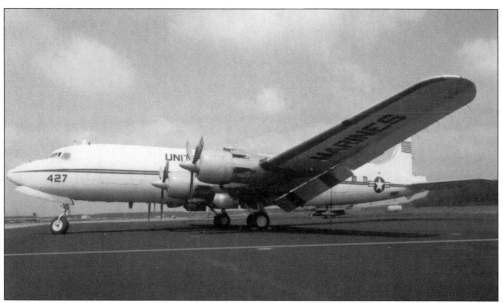

The C-118B Lift Master is a long range transport. In the 1950s it served as a personnel transport for the Marines. Some versions served as cargo aircraft. Cherry Point Marine Corps Air Station has been committed to operations all over the world with wing units deployed during the crisis in Lebanon, Cuba, the Dominican Republic, the Vietnam War, and the Persian Gulf War. (Photograph by Frances Eubanks.)

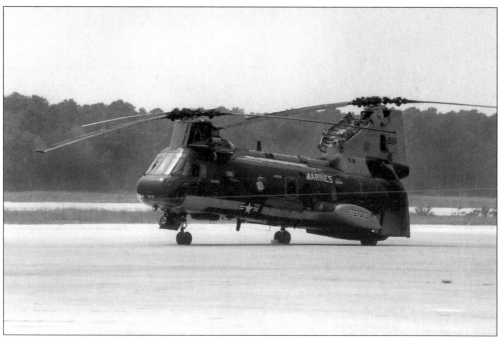

The varied and mostly treacherous terrain around the air station includes swamp, scrub, pocosin, rivers, lakes, and streams, and its location close to the Atlantic Ocean affords many opportunities to participate in air/sea rescue operations. One of the Sea Knight Air Rescue helicopters is pictured above. (Photograph by Frances Eubanks.)

A "bird bath" keeps the aircraft clean and removes salt residue after flying coastal maneuvers. (Photograph by Frances Eubanks.)

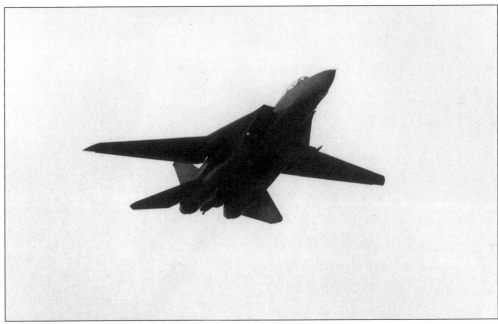

F-14 Tomcats, which incorporate "swing-wing" technology, are flown from Cherry Point. Upon takeoff, the wings on these planes are positioned straight out perpendicular from the fuselage for added lift, and when the craft reaches its cruising altitude the wings swing back to give the plane greater speed capabilities. This craft requires a pilot and a weapons officer. (Photograph by Frances Eubanks.)

The C-9B Sky Train II is a Marine's fleet logistics transport. It transports Marines and equipment to various parts of the world. (Photograph by Frances Eubanks.)

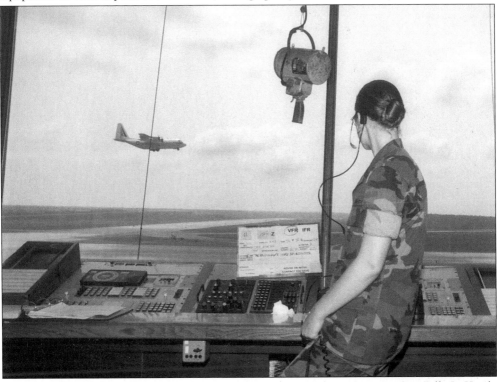

Women Marines play a role in the day-to-day operations of the air station. Sgt. Billy Jo Kettle is watching C130 Hercules touch-and-gos at the board. (Photograph by Frances Eubanks.)

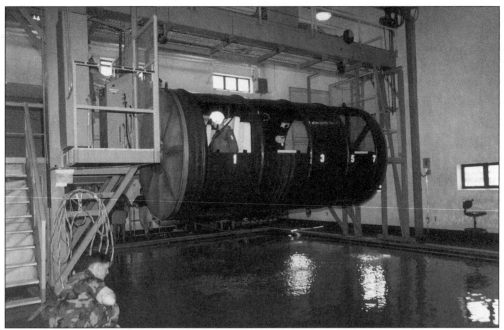

Cherry Point is known throughout the world for training pilots. The helicopter simulator drops pilots into the tank of water to simulate a helicopter going down in water at night. It submerges and rolls over with the pilot inside. The pilot has to learn to escape within a certain time period. (Photograph by Frances Eubanks.)

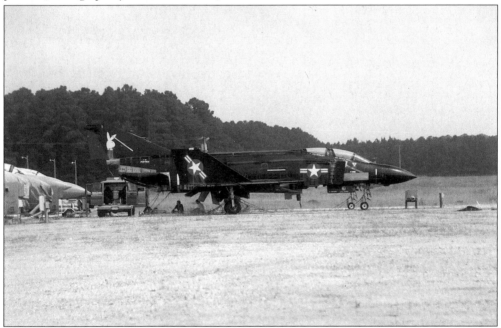

The F-4 Phantom II (a Vietnam-era jet) is known as one of the most classic jets ever built. It is no longer flown and sits stationary at the end of the runway in an area reserved for retired aircraft. This may one day be part of a special display by the Havelock Historical Society. (Photograph by Frances Eubanks.)

106

Six

A BRIDGE TO THE FUTURE, 2001

The gate to the past and the gate to the future were opened simultaneously with the reconstruction of the Tryon Palace, a crowning achievement for the citizens of Craven County. Originally built between 1767 and 1770, Tryon Palace was the official home of the colonial royal governor and also served as the capitol building for the colony. After the Revolutionary War, the structure was abandoned by the state, and in 1798, it was destroyed by fire. When Gertrude Carraway lead the charge to rebuild the palace she also lead the way into the future of Craven County.

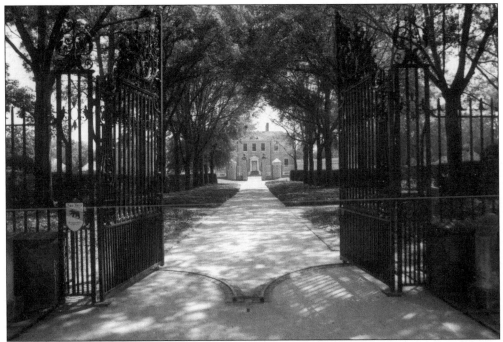

The efforts of the Tryon Palace Commission proved fateful, and the passion of the commission's members carried into the preservation of many other historical structures. After 30 years the palace has never looked more spectacular. It attracts thousands of visitors a year and has proven to be a boon to the local economy. (Photograph by Frances Eubanks.)

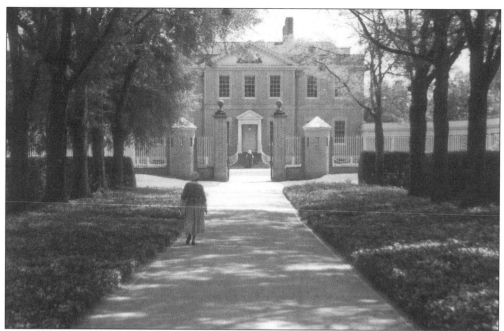

The carriage lane is hard-packed earth and leads to the main entrance of the stately mansion built for His Excellency, Royal Governor William Tryon. After the Revolutionary War the Assembly moved to Raleigh and the palace remained vacant for a few years before being destroyed by fire. (Photograph by Frances Eubanks.)

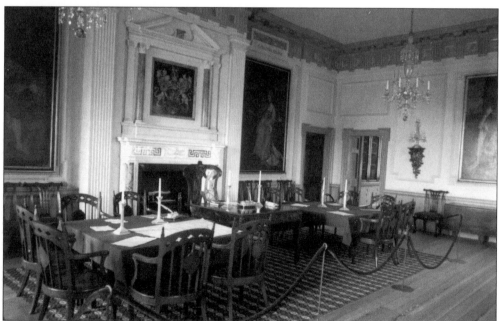

Governor Tryon's office was the place for the royal assembly meetings. No detail was spared in the construction and decoration of the palace and every element was thoroughly researched. Though most of the furniture and fixtures come from other periods and places, many original items have also been found. (Photograph by Frances Eubanks.)

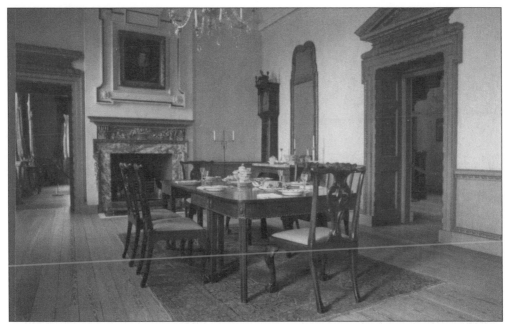

The dining room was the site of many formal dinners staged to entertain wealthy politicians and landowners, members of the royal court, European visitors, and dignitaries. Although all of the furniture is not authentic to the Palace, it is authentic to the period in which the Tryons lived in the Palace. Archivists were able to secure Tryon's personal inventory and used it as a guide while finishing the reconstructed building. (Photograph by Frances Eubanks.)

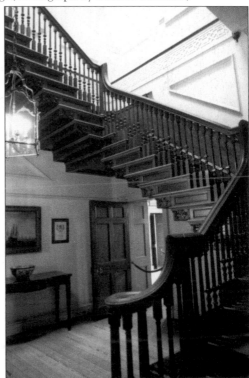

This grand and intricately hand-carved stairway is a focal point of the entrance and foyer of the house. (Photograph by Frances Eubanks.)

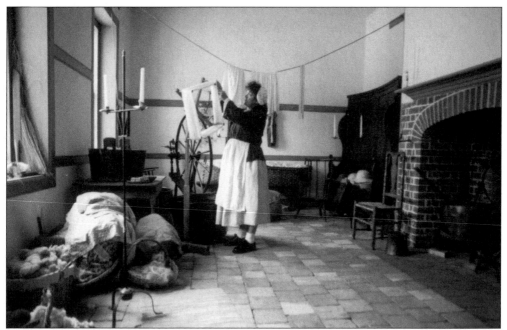

The laundry room, where household servants washed, dried, and repaired clothing, is on the first floor of the east wing, a handsome brick structure detached from the main building yet complementary in its design. The palace is open for tours and no detail has been spared in recreating a costumed interpretation of the royal period. (Photograph by Frances Eubanks.)

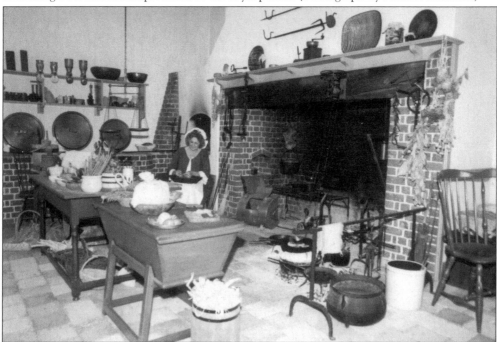

The kitchen was also located on the first floor of the east wing and was always bustling with activities related to the preparation of meals and tea for the Tryon family. Today reenactments are part of the daily tours at the palace. (Photograph by Frances Eubanks.)

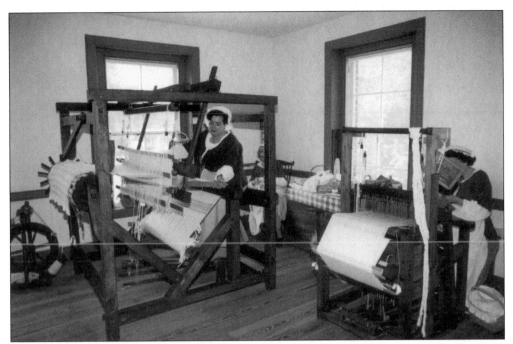

Weaver Rosemary Neubauer demonstrates weaving on a 200-year-old barn loom. In the 1700s the weaver was a peddler who traveled from town to town, set up his loom putting it together with dowels, and then took it apart again before moving on. Rosemary weaves 18th century patterns; it takes a week to thread the 950 threads.

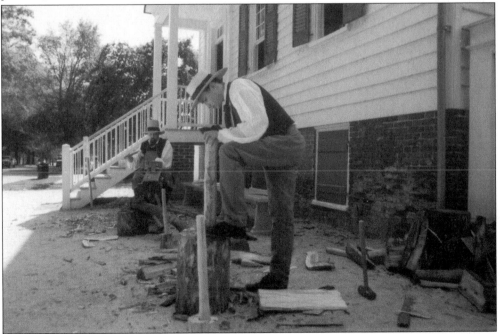

Living history at the Hay House is part of the daily tours at the Tryon Palace complex. Actors in period costumes interact with visitors as they portray the living conditions in the 1700s and early 1800s. (Photograph by Frances Eubanks.)

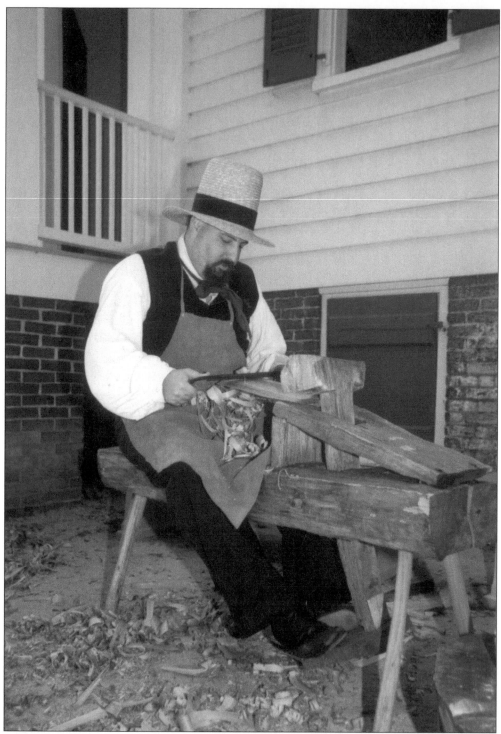

Andrew Duppstadt demonstrates the art of making wooden roof shingles in front of the Robert Hay House, named for a carriage maker of the 1830s. One of the missions of the Tryon Palace Commission is to interpret history for visitors. (Photograph by Frances Eubanks.)

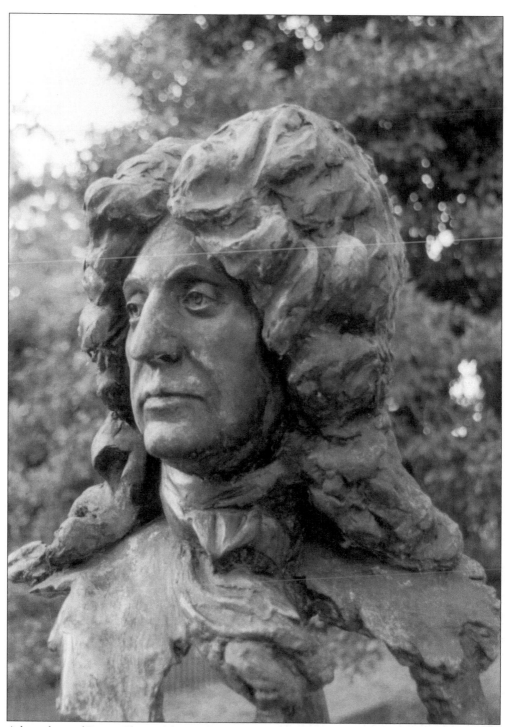

A large bust of Baron Christof de Graffenreid, the founder of New Bern, was commissioned for the 200th anniversary of the founding of the city. The location of New Bern, and thus Craven County, was not happenstance; rather, the baron carefully considered the location of his new colony in the New World. (Photograph by Frances Eubanks.)

At the April 2000 meeting of the deGraffenreid Society in New Bern, Wilda Thomas, a director and a deGraffenreid descendent, made a presentation in period costume. (Photograph by Frances Eubanks.)

The deGraffenreid Society has recorded the names of the thousands of deGraffenreid descendants that reside in the United States. The group's meetings bring together relatives from throughout the country that can directly trace their "roots" to the original Baron deGraffenreid. (Photograph by Frances Eubanks.)

There is still a Baron deGraffenreid who resides in Bern, Switzerland. Betty Thomas, president of the deGraffenreid Society, is pictured here as she awards him the deGraffenreid medal in April 2000. (Photograph by Frances Eubanks.)

The Baron and Baroness Helmut deGraffenreid are always welcome to New Bern and have traveled to their sister city several times to celebrate the Bern connection. (Photograph by Frances Eubanks.)

Pepsi Cola celebrated its 100th anniversary in 1999. The official birthplace of Pepsi was renovated and is now a museum, gift shop, and soda fountain. (Photograph by Frances Eubanks.)

The Pure Oil Station is now an attorney's office. Its renovation was an important reminder of the 1930s and 1940s era. (Photograph by Frances Eubanks.)

The skyline of New Bern has changed very little in the last 100 years, yet the land itself has made quite a transformation. This photograph was taken from the roof of the Sheraton Grand Hotel, which was constructed on the waterfront where old docks and warehouses were once located. Steeples and spires punctuate the sky and reflect the character of the 1800s. The Elk's building is the rectangular structure visible on the left. (Photograph by Frances Eubanks.)

This photograph was taken from the roof of Sheraton Grand Hotel, and captures a modern view of the confluence of the Trent and Neuse Rivers. This modern location of luxury boats and yachts is a far cry from the once-bustling waterfront of steamers, schooners, and other commercial sailing vessels. (Photograph by Frances Eubanks.)

The raft race in honor of Neuse River Day was held on June 3, 2000. This annual event is sponsored by the Neuse River Foundation and held at Union Point Park. The winners in the speed raft event were as follows: first place, *Lickety Split*; second place, *Procrastination*; and third place, *Right One Baby* (Pepsi raft). (Photograph by Frances Eubanks.)

Lickety Split's competitors display their winning form. The Neuse River Foundation's volunteers work to preserve the water quality of the river. (Photograph by Frances Eubanks.)

Waterfront parks have been a favorite gathering place for generations of Craven County residents, and the improvement of public waterfront areas has been an important part of urban renewal projects in New Bern. Union Park has recently undergone a facelift, and the walkways now connect to the new convention center across the street by a sidewalk that passes under the highway. The park was constructed in 1931 as part of a land reclamation project that turned the city-owned dump at Union Point into a community park. (Photograph by Frances Eubanks.)

The city of New Bern, which boasts a rich fire fighting heritage, opened a new fire department on Broad Street in 2000. (Photograph by Frances Eubanks.)

The new convention center, located on the Trent River next to the Sheraton Hotel, is pictured above while under construction in the fall of 2000. New Bern has a rich history of dances, music, and entertainment, and the convention center will have facilities to accommodate a wide variety of events. (Photograph by Frances Eubanks.)

Mr. Harvey emigrated from England to New Bern and constructed this house to serve as his private residence and his place of business. The main entrance was originally a carriageway right through the middle of the structure, which facilitated the loading and unloading of cargo from the docks that were in the back of the house. The Harvey Mansion is pictured here, c. 1904. (Courtesy North Carolina Division of Archives and History.)

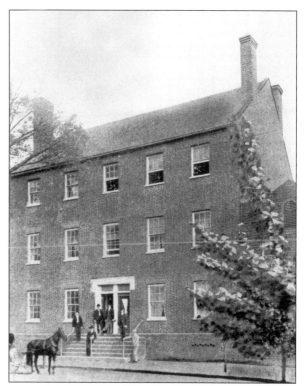

The back of the Harvey Mansion is pictured in 2000 from the roof of the Sheraton Grand Hotel. In the late 1700s the water of the Trent River came right up to the back entrance. The changes in the land mass are obvious as a vast area that was once water is now a vast parking lot. The Harvey Mansion is now a fine gourmet restaurant, and both the interior and exterior of the structure have been preserved for the generations to come. (Photograph by Frances Eubanks.)

Architectural detail is a hallmark of the New Bern's historic courthouse. As the county seat, New Bern needed a dignified structure to house the courtrooms, county offices, and public meeting rooms. This courthouse was constructed in 1883 and provided a permanent location for the court, which had moved three previous times. (Photograph by Frances Eubanks.)

The architectural detail on public buildings, homes, and even garden walls has been of interest to photographers for over 100 years. Many New Bern structures dating back to the 1700s exhibit intricate brickwork. (Photograph by Frances Eubanks.)

The city hall building, completed in 1897 for the federal government, first served New Bern as a United States Courthouse and post office. It has housed city hall since 1935 and still serves in that capacity today. (Photograph by Frances Eubanks.)

The City Hall clock is an important detail of the building. At the request of citizens of New Bern, a fine town clock was installed in 1907, but it was not long before the citizens realized that the clock face was too small. After repeated requests for a replacement, the existing clock was put into place in 1911. (Photograph by Frances Eubanks.)

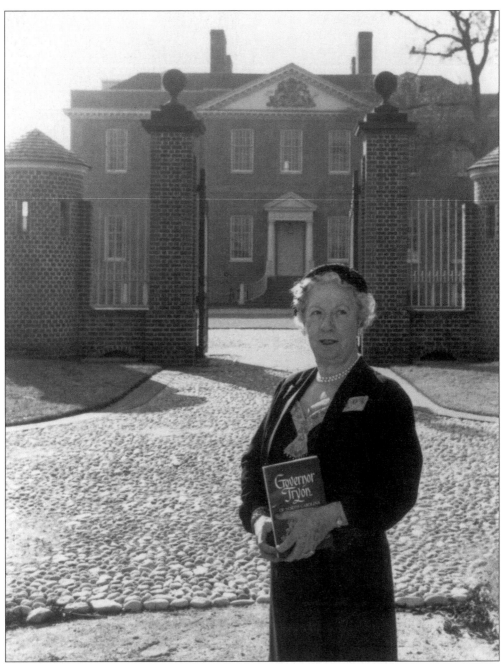

Gertrude Carraway will long be remembered for her many contributions to New Bern. She was an author, a newspaperwoman, and a devoted member and national president of the Daughters of the American Revolution. Her efforts, coupled with endowments from several prominent North Carolinians, made the reconstruction of the Tryon Palace possible. According to her nephew Col. Joe Carraway, she was also the guiding light of her family. Joe said that his Aunt Rose, Gertrude's sister, was also a grand historian. Their love of New Bern and their contributions will be long remembered. (Courtesy North Carolina Division of Archives and History.)

In 1879 Atlantic Steamer Atlantic Hook and Ladder Company received this Silsby Steam Fire Engine. There was great competition between fire companies to see who had the best equipment and who could arrive at a fire first. The New Bern Firemen's Museum has a unique collection of antique fire-fighting displays. (Photograph by Frances Eubanks with permission from the New Bern Firemen's Museum.)

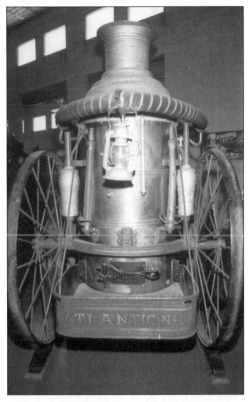

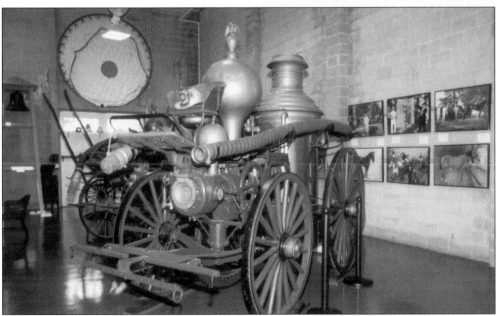

The 1884 Button Steamer Fire Engine was purchased for the New Bern Steam Fire Engine Company No. 1. Unlike the first steam engines which had to be pulled to a fire by a 16-man crew, this one was horse drawn. The company was known as the Button Company. (Photograph by Frances Eubanks with permission from the New Bern Firemen's Museum.)

The canon from Stanley's privateer still stands guard over the New Bern waterfront. The remnants of the Broad Street Bridge are still visible though the bridge was demolished in 1999 when the new Neuse River Bridge opened. (Photograph by Frances Eubanks.)

The Elks Temple, the large center building, rises above the cityscape in 2000. The downtown skyline is little changed from the 1920s and 30s. The Elks replaced and earlier frame building; the new building was designed by William Rose of Raleigh and completed in 1908. (Photo taken from the roof of the Sheraton Grand by Frances Eubanks.)

New waterfront improvements include a promenade on the water's edge at Union Park. This walkway connects to the new convention center by a path under the Trent River Bridge. (Photograph by Frances Eubanks.)

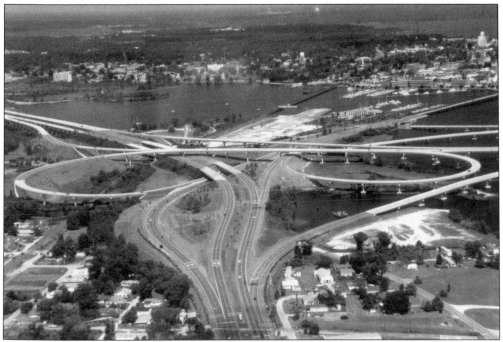

The new Neuse River Bridge opened in 1999. The $120 million bridge fulfills the dreams of the fathers of the county; it connects the entire county to a modern highway system. (Photograph by Frances Eubanks.)

New Bern is known for its soaring spires and steeples. (Photograph by Frances Eubanks.)

ABOUT THE AUTHOR

Lynn Salsi is dedicated to recording North Carolina history in children's books, non-fiction accounts, and historical fiction. Her plays for children have been produced in North Carolina; Washington, D.C.; Baltimore; New York City; and London, England. She is well known for enrichment presentations in schools and colleges.

Lynn enjoys viewing history through the eyes of those who have lived it. She lives in Greensboro with her husband and two children. She is active in arts in education, the Piedmont Children's Book Festival, and Boy Scouts and loves inspiring children to write.

ABOUT THE PHOTOGRAPHER

Frances Eubanks's photographs have been featured in books, museums, and touring shows and have been included in permanent collections. Her work has appeared on magazine covers and in magazine and newspaper articles. Frances has spent 30 years as an award-winning professional photographer. Her awards have been many and have placed her work on covers and in shows for the Core Sound Waterfowl Museum and the North Carolina Seafood Festival. She is dedicated to preserving North Carolina visual history. She lends her vast personal "first-person" knowledge of coastal history to her images. Frances lives with her husband in Newport and has two children and two grandchildren.

Frances and Lynn share a passion for recording the history of elder citizens in words and photographs, so "their stories will never be lost." They are the recipients of the Willie Parker Peace History Book Award from the North Carolina Society of Historians for *Images of America: Carteret County* (Arcadia Publishing).